IMAGES
of America

LIGHTHOUSES AND LIFESAVING ON
WASHINGTON'S
OUTER COAST

ON THE COVER: This c. 1910 photograph shows the crew of the U.S. Life-Saving Service station at Willapa Bay's North Cove posing in their lifeboat. Severe erosion led to the station in the background washing away in the 1960s. The Coast Guard rebuilt it to the southeast, on Toke Point in the bay. (Courtesy of Pacific County Historical Society.)

IMAGES of America
LIGHTHOUSES AND LIFESAVING ON WASHINGTON'S OUTER COAST

William S. Hanable

ARCADIA
PUBLISHING

Copyright © 2008 by William S. Hanable
ISBN 978-0-7385-5971-1

Published by Arcadia Publishing
Charleston SC, Chicago IL, Portsmouth NH, San Francisco CA

Printed in the United States of America

Library of Congress Catalog Card Number: 2008933020

For all general information contact Arcadia Publishing at:
Telephone 843-853-2070
Fax 843-853-0044
E-mail sales@arcadiapublishing.com
For customer service and orders:
Toll-Free 1-888-313-2665

Visit us on the Internet at www.arcadiapublishing.com

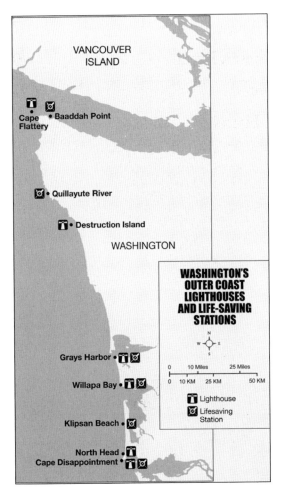

The lighthouses and lifesaving stations of Washington's outer coast dotted that coast from Cape Disappointment at the mouth of the Columbia River to Cape Flattery at the entrance to the Strait of Juan de Fuca.

Contents

Acknowledgments		6
Introduction		7
1.	Cape Disappointment to Klipsan Beach	9
2.	Willapa Bay to Grays Harbor	51
3.	Destruction Island to Cape Flattery	95
Selected Bibliography		126
Index		127

Acknowledgments

I am deeply indebted to the many people who allowed me access to their collections, aided in my search for images, and helped in so many other ways. They include T. J. Barcelona and Rex Martin, Westport Maritime Museum; Kathleen Crosman and Tracy Vasquez, Pacific Alaska Region, National Archives and Records Administration; Capt. Gene Davis, U.S. Coast Guard–retired, and Larry Dubia, Coast Guard Museum Northwest; Howard Giske and Terri Middleton, Jones Historical Photo Collection; Beverly Olson and Claudette Kelly, Pacific County Historical Society; John Larson and John Lucas, Polson Museum; Donella Lucero, Long Beach Area State Parks; Barbara Menard and Joan Mann, Columbia Pacific Heritage Center; Elaine Miller, Washington State History Research Center; Kathryn Monds, Clallam County Historical Society; Dave Pearson and Jeff Smith, Columbia River Maritime Museum; Bob Steelquist, Olympic Coast National Marine Sanctuary; and Laura Waayers, Naval Historical Foundation.

INTRODUCTION

Washington's outer coast lighthouses and lifesaving stations have clustered around and linked maritime approaches to the resource-rich Puget Basin. The basin is bounded on the north by the northern tip of Vancouver Island, on the east by the Cascade Mountains, on the west by the Pacific Ocean, and the south merges into the Willamette Valley. Access points to the basin from the sea include the entrances to the Columbia River, Shoalwater Bay (renamed Willapa Bay sometime after 1900), Grays Harbor, and the Strait of Juan de Fuca.

In the late 1700s, European and American maritime explorers and fur traders followed Native Americans in plying these waters. The Native Americans were skilled users of the sea. When the first lifesaving stations were established on Washington's outer coast, many would take places at the oars of boats making rescues. This was particularly true in the earliest years when a station's complement might consist only of a keeper, who would have to round up volunteers to meet emergencies. In 1884, for instance, when the bark *Lizzie Marshall* stranded in the Strait of Juan de Fuca on Vancouver Island's Bonilla Point, the lifesaving station at Neah Bay had no crew on duty. The keeper had the help of four Makah Indians on one day and eight the next. Native Americans also rescued mariners in distress on their own initiative. Quinault Jonas Jones was awarded a silver lifesaving medal for rescuing the entire crew of the schooner *Lily Grace*, wrecked near Grays Harbor in January 1887, and, about a year later, for rescuing three crew of the British ship *Abeercorn* not far from same place. Thus, it was ironic that in most cases lighthouses and lifesaving stations were built on traditional tribal lands, often acquired with minimal compensation, to meet the needs of an expanding maritime commerce along and to Washington's outer coast.

There was, however, little evidence of that commerce until the California Gold Rush of 1849 created a market for farm, forest, and fish products of the Puget Basin. Willamette Valley farmers shipped wheat south via the Columbia River and then by sea. Puget Sound and Grays Harbor loggers shipped lumber south. Shoalwater Bay fishermen harvested delicacies from the bay's oyster beds and shipped them south, too.

About the same time this demand for the Puget Basin's forest and fish resources arose, Britain ceded to the United States control of what had been a jointly administered "Oregon Territory." Congress established a new American Oregon Territory that soon split, in part, into the coastal states of Washington and Oregon.

The U.S. Coast Survey began to chart America's newly acquired shoreline and to identify waters needing lighthouses and buoys. Congressional authorization and funding for lighthouse construction at the Columbia River, Shoalwater Bay, and the Strait of Juan de Fuca followed. Settlers on Grays Harbor pleaded, with eventual success, for their own lighthouse. Experience and events, often tragic, would prove that additional lights were needed at Destruction Island, North Head, Umatilla Reef, and Swiftsure Bank.

Each of the maritime approaches to the Puget Basin had its own particular dangers. Seafarers using them were often in distress. Authorities charged lighthouse keepers with lifesaving duties when practical, but lighthouse staffs were small and it took time to round up volunteer lifesavers

when they were needed. The lighthouse at Cape Disappointment listed both a "lighthouse boat" and a "life boat" in its inventory. The need for the latter was tragically demonstrated when an assistant lighthouse keeper drowned while crossing the Columbia on a routine trip to Astoria for supplies.

In 1874, Congress authorized staffed lifeboat stations on the Pacific Coast. The stations included Cape Disappointment, Shoalwater Bay, and Neah Bay on the Strait of Juan de Fuca. Stations at Grays Harbor, Klipsan Beach, and Quillayute River opened later. This was the same year Shoalwater Bay oyster catchers shipped 120,000 baskets of their product to San Francisco, millions of bushels of wheat passed out of the Columbia River on their way to market, and the forerunners of millions of board feet of lumber left Puget Sound and Grays Harbor headed for destinations all over the world.

Authorization for staffed stations, however, did not mean that full-time, trained crews were immediately on duty. Depending on perceived needs of a particular station, staffing might mean a full-time keeper expected to round up volunteers or a full-time keeper overseeing a crew on duty for only part of the year. Full-time crews were soon in place, however.

By 1900, Washington's outer coast had a chain of lighthouses and lifesaving stations stretching from Cape Disappointment at the mouth of the Columbia River to Neah Bay, just inside Cape Flattery in the Strait of Juan de Fuca. These linked aids to navigation increased over the coming years as maritime traffic grew.

The aids to navigation also changed, as new technologies such as radio communication, radio beacons, and radio direction finding became available. The navigation aids eventually included lightships as well as lighthouses and lifesaving stations. Although changing, the chain continued to fulfill its intended purpose of assisting mariners entering and leaving the Puget Basin. Its links clustered around the Columbia River entrance, Shoalwater Bay, Grays Harbor, and the Strait of Juan de Fuca.

Photograph records of the lighthouses and lifesaving stations of Washington's outer coast are incomplete. Few photographers were around during their earliest days. When more photographers were around, technological limitations resulted in few views of lighthouse interiors. The circumstances of lifesavers' work usually meant that although some rescues from the beach were documented, rescues at sea seldom if ever had photographers present. There are, however, many surviving photographs. Some of the most interesting of these are presented in the following pages.

One
Cape Disappointment to Klipsan Beach

The Columbia River presents formidable challenges to ships attempting to enter or leave it. Its outflow can reach a volume of one million cubic feet per second. At the river's mouth, sandbars have formed that stretch out for a great distance on either side. Cross tides change every half-hour.

A 21st-century comment by historian Dennis Noble, a retired U.S. Coast Guard senior chief petty officer, is equally ominous: "The mouth of the Columbia River is one of the most treacherous areas for mariners in the world. . . . The depth of the water begins to shallow and forms what sailors call a bar. When the ocean waves go from deep to shallow in a very short distance, they 'feel bottom' and this causes steep waves. The steeper the waves, the more chance for them to break, and breaking waves are the most powerful seas a mariner must face." This expert goes on to explain that many wintertime low-pressure systems entering the United States cross Washington's outer coast, causing high winds and rain close to the coast. At the mouth of the Columbia, such winds push ocean waves against the river's bar. Steep breaking waves result, while the river's outflow and tidal forces compound the challenges facing ships that wish to cross the bar or have to operate in the vicinity of the river's mouth.

The area's Chinook Indians crossed the Columbia River bar in their canoes for many centuries before Spanish explorers, perhaps as early as 1603 and definitely on August 17, 1775, identified and charted the river entrance. It was left to American fur trader Robert Gray, sailing in the *Columbia Rediviva*, to give the cape the name that lasted. Frustrated in efforts in the spring of 1792 to enter the river, he labeled the place Cape Disappointment.

The Columbia River entrance is clearly a location where navigators need all the help they can get. In 1850, Coast Survey Sub-Assistant A. M. Harrison, writing from a camp on Cape Disappointment, recommended that a lighthouse be built on the southwest extremity of the cape. From that start, lighthouses would be built on both sides of the river entrance, a lightship would be stationed there, and lifesaving stations would be built not only at the cape, but also on the south side of the Columbia as well as farther north. The lifesaving station farther north was on the ocean side of what is now called the Long Beach Peninsula. It is a long sandy spit that extends north from Cape Disappointment to form the southern arm bordering what was then called Shoalwater Bay.

The documentation that resulted in placing Cape Disappointment Historic District on America's National Register of Historic Places noted that the cape is known to have been the location of more than 250 shipwrecks. A few have been photographed.

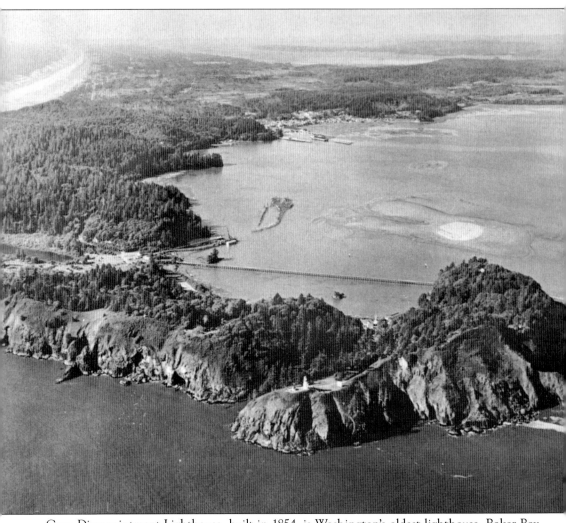

Cape Disappointment Lighthouse, built in 1854, is Washington's oldest lighthouse. Baker Bay can be seen on the other side of the cape. Cape Disappointment Life-Saving Station, which now includes the National Motor Lifeboat School, fronts on Baker Bay and is just out of sight at the end of the road leading up the cape to the lighthouse. In the background, the Long Beach Peninsula stretches away to the north. (Courtesy of Columbia Pacific Heritage Museum.)

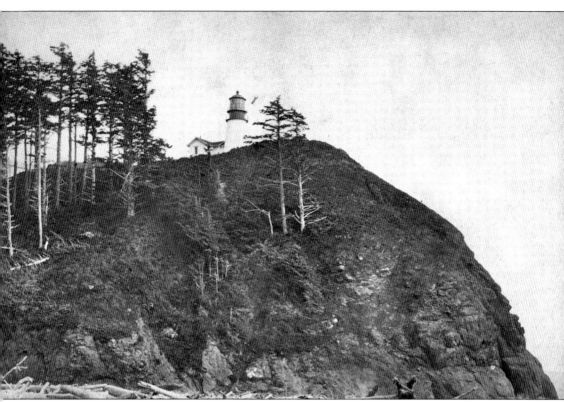

Named by seagoing fur trader John Meares in 1788 when he thought he had not found the mouth of the Columbia, Cape Disappointment rises 220 feet above the Pacific. Land around the lighthouse drops abruptly to the ocean below. Although a contractor completed the lighthouse in 1854, its first-order Fresnel lens did not arrive until 1856 because of a change in the type of lens being installed. (Courtesy of Columbia Pacific Heritage Museum.)

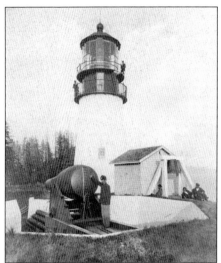

The cannon in this photograph is a 15-inch Rodman smooth-bore gun. In 1871, the frame for the fog bell in front of the lighthouse was shattered by a cannon blast. The army removed this battery in 1885 when upgrading the cape's fortifications. (Courtesy of Coast Guard Museum Northwest.)

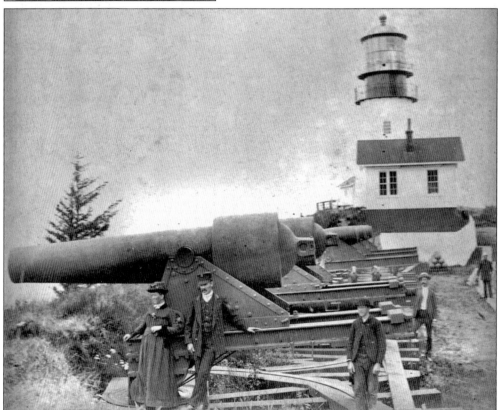

After the American Civil War started in 1861, the U.S. Army built artillery batteries on Cape Disappointment. In February 1865, keeper John Boyd wrote to the district lighthouse engineer that the firing of cannon was breaking windows in the lighthouse. The engineer advised Boyd to open all the windows and to see to "precautions taken if possible to prevent injury to the lens, lamp, and other pieces of apparatus connected with the lighthouse." This cannot have been welcome advice, since Boyd had complained earlier of the "unbearable cold" in the tower. (Courtesy of Columbia Pacific Heritage Museum.)

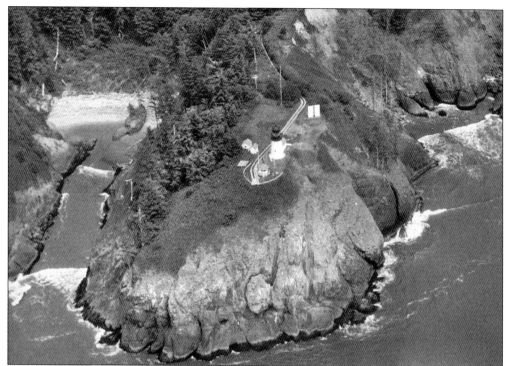

An octagonal watch building is in front of Cape Disappointment Lighthouse. Similar structures have been features of the light station from its inception. Life-Saving Service personnel from the station on the Baker Bay side of the cape climbed to the light station and from there kept watch over the hazardous waters below. They could alert the lifesaving crew when needed. (Courtesy of Pacific Alaska Region, National Archives and Records Administration.)

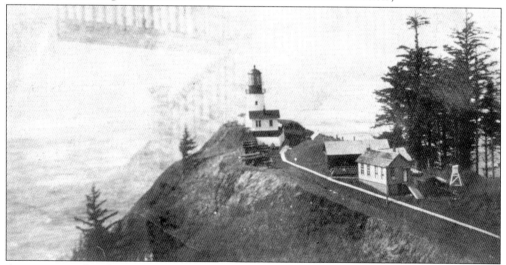

A narrow wood walkway led up the crest of Cape Disappointment to the lighthouse. Although the keepers' quarters were immediately behind, or east of, the lighthouse, other structures sprouted up along the path over the years. To the left can be seen an early Weather Bureau station and beyond it an army shed to the right and artillery battery to the left of the walkway. (Courtesy of Columbia Pacific Heritage Museum.)

Cape Disappointment Lighthouse personnel initially lived in a small house immediately behind the lighthouse. In 1871, a larger keeper's residence was built below the lighthouse partway up the one-third-of-a-mile slope between it and the lifesaving station on Baker Bay. The buildings of Fort Canby, which was called Fort Cape Disappointment until 1875, are in the background. (Courtesy of Columbia Pacific Heritage Museum.)

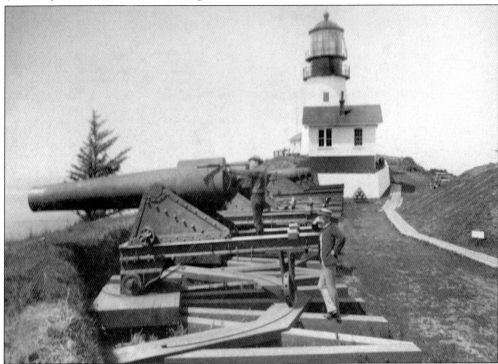

The Cape Disappointment Lighthouse design altered those typical of West Coast lights on a high promontory. These were usually short towers integrated into a dwelling. At Cape Disappointment, the builder separated the 53-foot tower and the dwelling because of the steep terrain. In the foreground of this picture, a keeper with a telescope peers southward while a dandy in straw boater poses for the photographer. (Courtesy of Coast Guard Museum Northwest.)

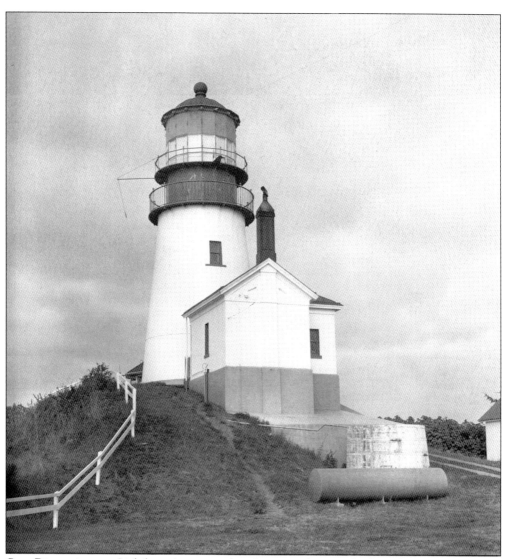

Cape Disappointment Lighthouse's concrete foundation can be seen clearly in this 1955 photograph. In 1899, Carl W. Leick, who designed many of Washington's lighthouses, drew up plans for the workroom built behind the lighthouse where the original keepers' dwelling once stood. The artillery batteries around the lighthouse were removed after World War II. (Courtesy of Pacific Alaska Region, National Archives and Records Administration.)

America's first contribution to lifesaving in the Cape Disappointment area came in 1841 after the U.S. Navy's ship *Peacock*, part of the U.S. Exploring Expedition, wrecked on the spit that later bore her name. The *Peacock*'s boats are rowing toward shore after the wreck. When the expedition sailed away, Cmdr. Charles Wilkes gave one of the boats to the Hudson's Bay Company Astoria post, hoping it could be used to save other shipwreck victims. (Courtesy of Naval Historical Foundation.)

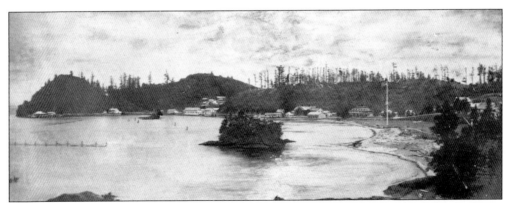

Baker Bay, inside Cape Disappointment, provided sheltered water close to the Columbia River entrance. It was a good spot for a lifesaving station and was already bordered by a government reservation. It seemed a good spot to build after the Civil War. (Courtesy of Pacific County Historical Society.)

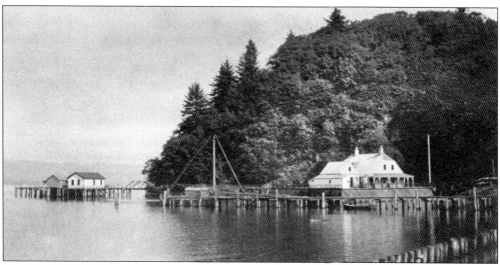

The first U.S. Life-Saving Service station's main building at Cape Disappointment was built in 1877 on piles sunk into Baker Bay. Its surfboat was housed in an adjacent building. A long dock led to a boathouse in which the station's lifeboat was kept. Cape Disappointment Lighthouse is out of sight on the seaward side of the cape. (Courtesy of Pacific County Historical Society.)

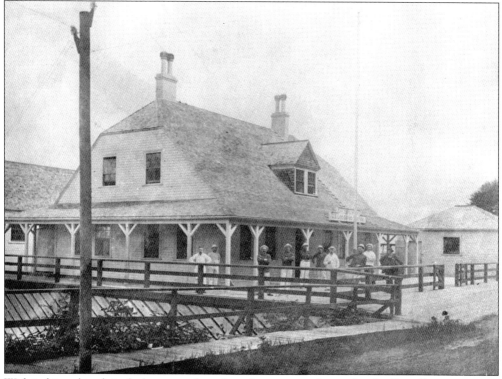

With its hipped roof, single dormer, and porch roof running on three sides, the Cape Disappointment Life-Saving Station was architecturally unique. The building behind the main structure housed a surfboat, beach cart, firefighting apparatus, and other tools. The dog posing with the men in front of the station was one of many mascots to be found at lifesaving and light stations. (Courtesy of Columbia River Maritime Museum.)

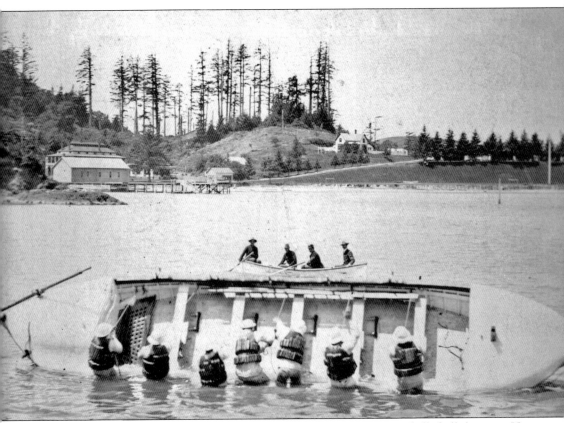

Like lifesaving crews at other stations, people at Cape Disappointment drilled all the time. Here the lifeboat crew practices righting their craft while in the water of Baker Bay. An adept keeper, it was said, could leap from inside the boat to the hull without getting his feet wet during a drill. In this picture, however, the keeper seems to be in the water with his six-man crew. (Courtesy of Columbia River Maritime Museum.)

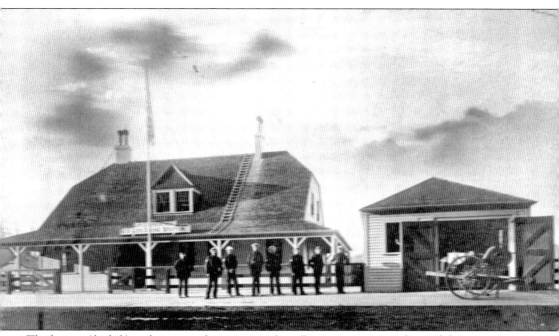

The keeper (far left) and seven surfmen pose at Cape Disappointment in front of the station. A beach cart, used to carry lifesaving apparatus, is to the right in front of an equipment building. (Courtesy of Columbia River Maritime Museum.)

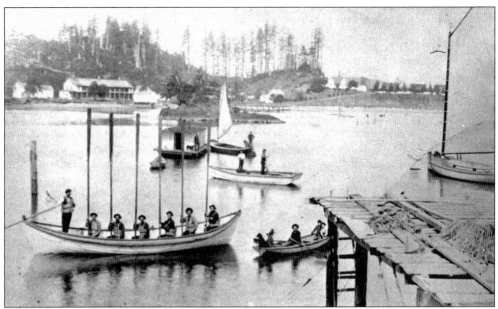

Cape Disappointment's keeper and six of its seven surfmen pose with "tossed oars" in their surfboat in Baker Bay. Their drills usually attracted an audience, as evidenced by the skiff to the right filled with dogs and children. The seventh surfman may have been on watch at the lookout near the lighthouse. (Courtesy of Columbia Pacific Heritage Museum.)

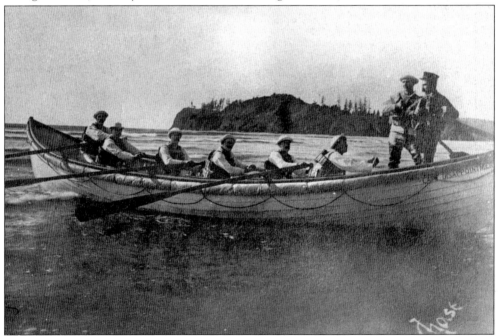

All seven surfmen and the keeper of Cape Disappointment Life-Saving Station are off the cape in their surfboat. They made regular patrols in these waters. Canneries upriver sent small sailboats with two-man crews out each day with gill nets during salmon runs. Preoccupied with their gill nets, the fishing crews were often caught unaware by rising tides, strong winds, and shifting currents. Capsizes were frequent. (Courtesy of Coast Guard Museum Northwest.)

Life-saving Service publications reported that as many as 1,000 two-man gillnetters could be found at the mouth of the Columbia on a single day. They could "be thrown in confusion in and out of the troughs of monstrous surges or overcombed by unexpected waves" in combinations of strong winds, river current, and tide changes. (Courtesy of Columbia River Maritime Museum.)

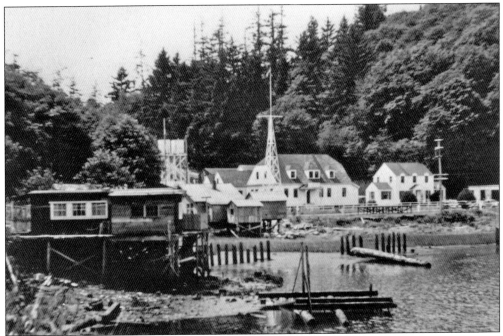

In 1896–1897, the Life-Saving Service rebuilt its Cape Disappointment station. It was relocated from its pilings to the banks of Baker Bay. The porch has been removed and one dormer added on either side of the front dormer. The tower to the left of the building supports a staff and signal flag. (Courtesy of Museum of History and Industry., Seattle)

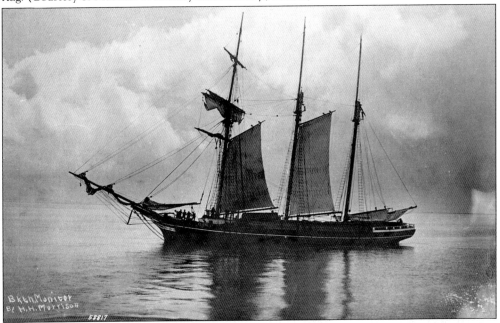

Cape Disappointment's keeper and surfmen not only rescued crews of small fishing boats, they also aided crews of larger craft. The barkentine *Monitor*, built at San Francisco in 1862 and shown here, foundered off the Columbia on March 24, 1901. (Courtesy of Washington State Historical Society, Tacoma.)

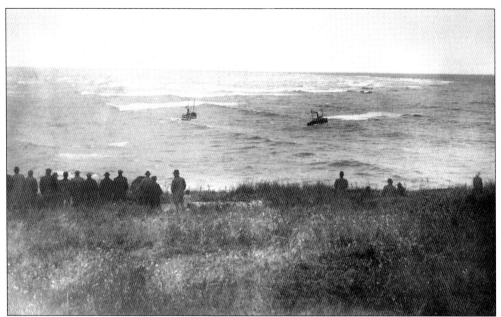

The Cape Disappointment lifesavers were not involved in all rescues at the mouth of the Columbia River. On November 11, 1911, winds and current swept the steam lumber schooner *Washington* toward Peacock Spit after she became disabled when crossing the Columbia River bar. Spectators watched from Cape Disappointment as the tug *Tatoosh* pulled the schooner with its 25 passengers and 24 crewmen out of surf breaking on the spit. (Courtesy of Washington State Historical Society, Tacoma.)

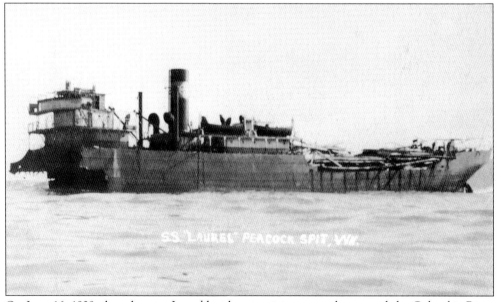

On June 16, 1929, the schooner *Laurel* lost her steering gear as she crossed the Columbia River bar outbound with a cargo of lumber. Driven onto Peacock Spit, she began to break up. Coast Guardsmen rescued all of the crew the next day. Two days later, the Cape Disappointment lifeboat removed the *Laurel*'s captain, Louis Johnson, who had remained with his ship. (Courtesy of Washington State Historical Society, Tacoma.)

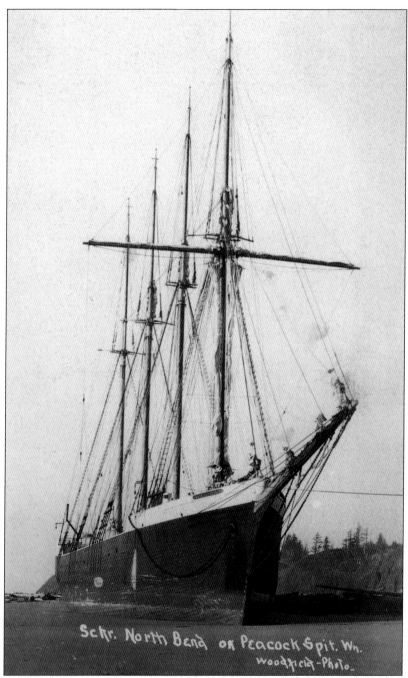

The four-masted schooner *North Bend*, returning from Australia where she had delivered a cargo of lumber, was driven onto Peacock Spit when attempting to cross the Columbia River bar on February 15, 1928. The Cape Disappointment lifesavers removed the crew. The Coast Guard rescue tug *Snohomish* and the Astoria *Tug No. 3* then pulled the schooner free, but lines parted and the *North Bend* ended up high on the beach. She remained there for 13 months. In 1929, wind and current washed beach sands away so that the *North Bend* refloated herself in Baker Bay. (Courtesy of Washington State Historical Society, Tacoma.)

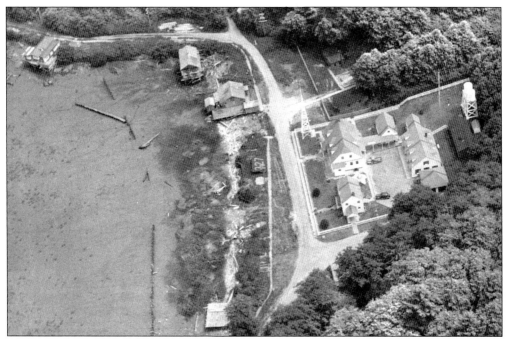

As this 1947 aerial view shows, the original Cape Disappointment Life-Saving structure survived World War II. The complex around it has grown considerably. After the National Motor Lifeboat School was added to the station, a new multipurpose structure replaced the old building. (Courtesy of Pacific Alaska Region, National Archives and Records Administration.)

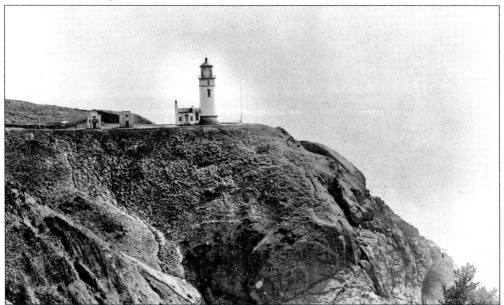

The Cape Disappointment light was often above, and difficult to see through, thick fogs that frequently blanketed the area. As a result, in 1898, a new lighthouse was built on North Head and Cape Disappointment's first-order Fresnel lens moved there. This shows the new tower, its attached workroom, and the two oil storage houses behind it. At Cape Disappointment, a fourth-order light replaced the larger beacon. (Courtesy of Pacific County Historical Society.)

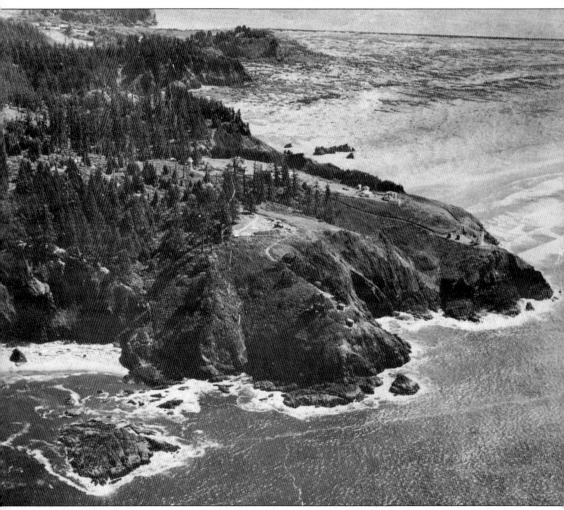

Somewhat confusingly, the entire area known as Cape Disappointment includes three promontories. These are Cape Disappointment (site of the 1854 lighthouse), North Head, and McKenzie Head. McKenzie Head lies between the other two outcroppings. The light station that opened at North Head in 1898 included the lighthouse and oil storage houses and also keeper's and assistant keepers' dwellings some distance away. (Courtesy of Columbia Pacific Heritage Museum.)

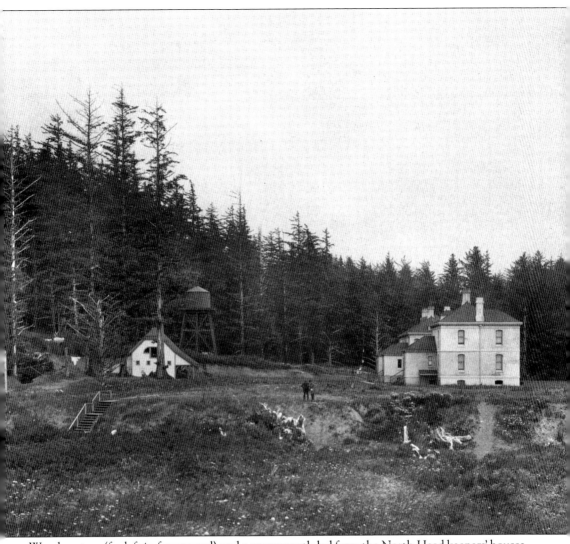

Wooden steps (far left in foreground) and a narrow path led from the North Head keepers' houses to the lighthouse. Lighthouse officials provided for a small barn (far left in background) at the station. (Courtesy of Columbia Pacific Heritage Museum.)

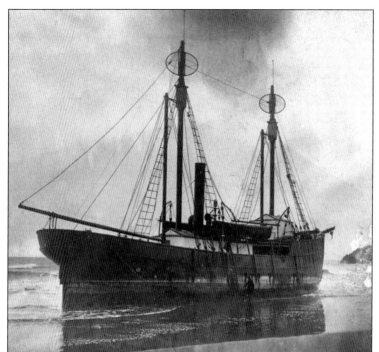

Sail-powered Columbia River *Lightship No. 50* normally anchored southwest of Cape Disappointment. About 6:30 p.m., November 29, 1899, her cable parted. Despite efforts by tugs and the lighthouse tender *Manzanita*, the lightship drifted ashore the next day near McKenzie Head. Cape Disappointment lifesaving personnel took the crew off with breeches buoy apparatus. (Courtesy of Washington State Historical Society, Tacoma.)

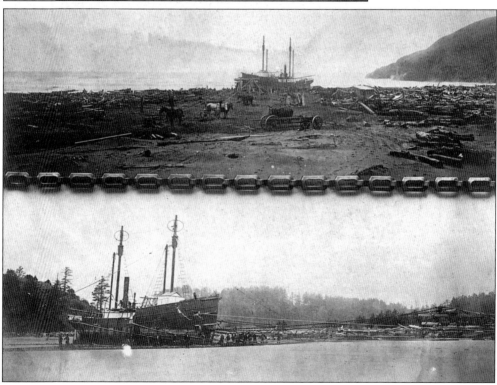

After attempts to tow *Lightship No. 50* off the beach failed, Lighthouse Service authorities decided to tow her overland to Baker Bay and relaunch there. The ship was lightened, contractors hired, and the tow began. (Courtesy of Columbia Pacific Heritage Museum.)

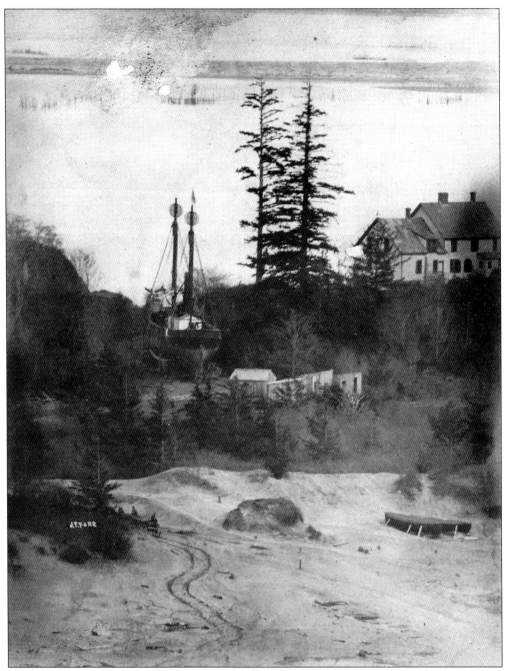

Lightship No. 50 left the sandy ocean beach below Cape Disappointment to cross through the narrow ravine between the cape and McKenzie Head to the north on a specially constructed marine railway. The lighthouse keeper's quarters, halfway up the cape between Baker Bay and the lighthouse, are to the right. (Courtesy of Washington State Historical Society, Tacoma.)

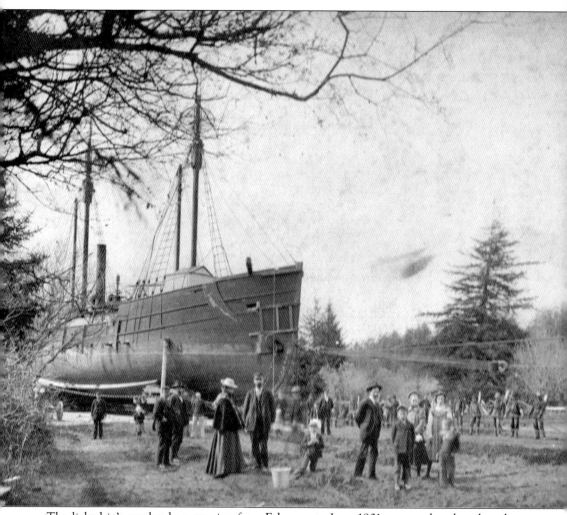
The lightship's overland progression from February to June 1901—ocean beach to bay shore—became a sightseeing attraction for area visitors and for residents. (Courtesy of Columbia Pacific Heritage Museum.)

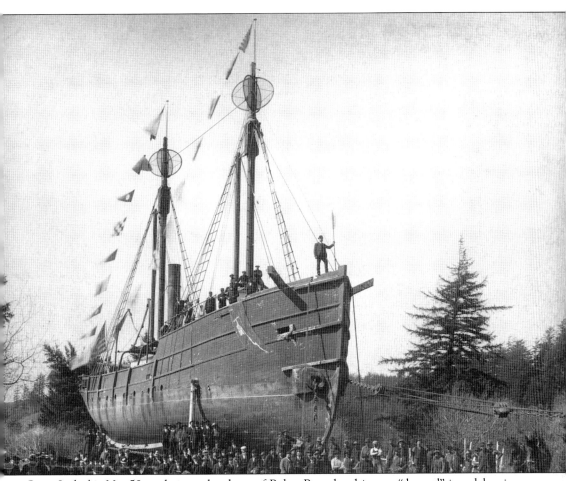

Once *Lightship No. 50* made it to the shore of Baker Bay, the ship was "dressed" in celebration before she was relaunched on June 2, 1901. David Pinyerd provides a detailed account of *No. 50*'s journey in his *Lighthouses and Life-Saving on the Oregon Coast* (Arcadia Publishing, 2007).

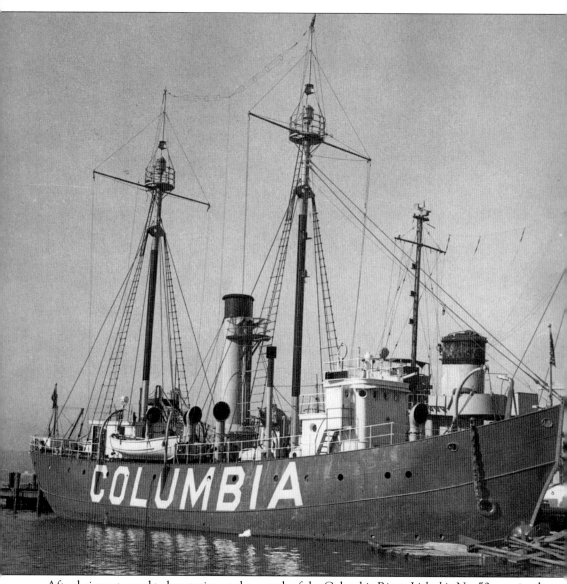

After being returned to her station at the mouth of the Columbia River, *Lightship No. 50* remained there until 1909 when retired. A series of other lightships replaced her. The last lightship at the Columbia River entrance was replaced by a lighted buoy in 1979. (Courtesy of Pacific Alaska Region, National Archives and Records Administration.)

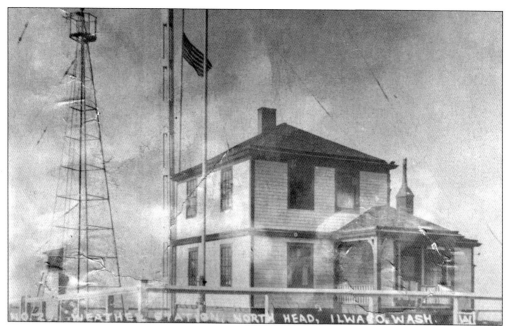

In 1902, a weather station was established on light station grounds at North Head. It succeeded an earlier one at Fort Canby that was maintained from 1864 to 1899. On January 29, 1921, gusts of up to 160 miles per hour were unofficially recorded after a windstorm destroyed all the weather bureau's instruments at the site. (Courtesy of Columbia Pacific Heritage Museum.)

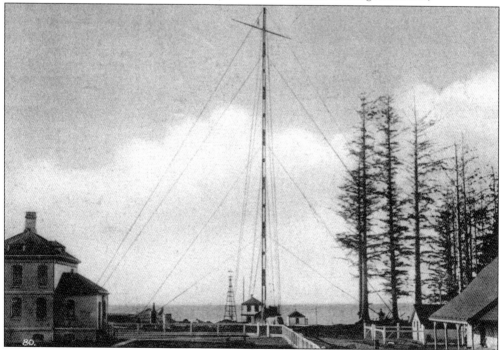

Weather station buildings can be seen beyond the radio mast in this photograph. The North Head Light's assistant keepers' quarters are to the left, and the light station's barn is in the right foreground. (Courtesy of Columbia Pacific Heritage Museum.)

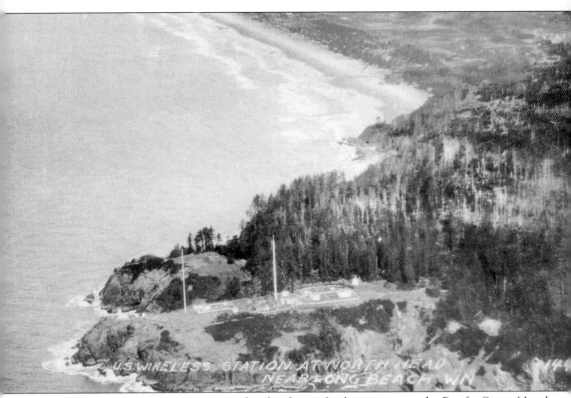

In 1907, the Navy Department completed a chain of radio stations on the Pacific Coast. Naval Radio Station North Head, call sign NPE, was one of them. Its buildings and antennae occupied the ground between the lighthouse keepers' quarters and the lighthouse, sharing that space with the weather station. (Courtesy of Columbia Pacific Heritage Museum.)

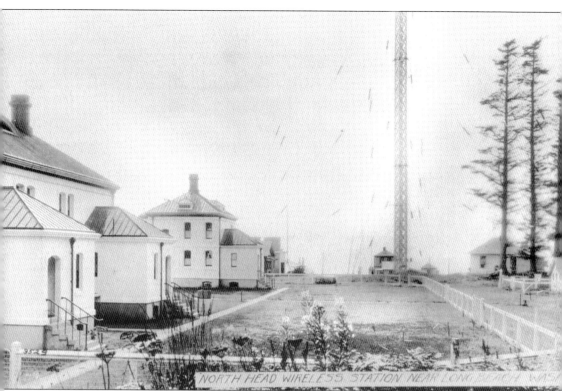

Naval Radio Station North Head buildings lie beyond the head lighthouse keeper's dwelling on the far left. One of the station's 200-foot steel antenna towers is in the center background. The radio station sent out time signals, notices of hazards to navigation, and messages to and from ships at sea. (Courtesy of Columbia Pacific Heritage Museum.)

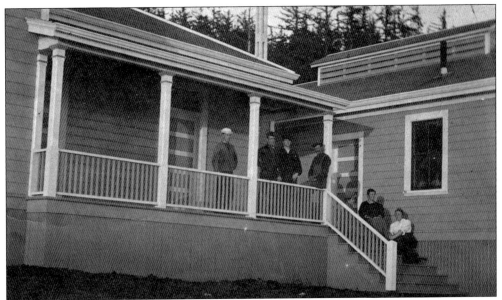

Naval Radio Station North Head operators and family members pose on the porch of one of the station's buildings. One of the steel antenna towers is in the background. (Courtesy of Columbia River Maritime Museum.)

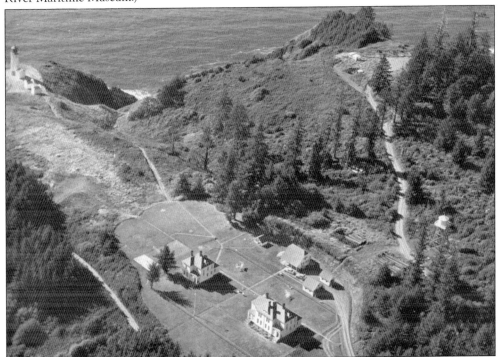

In this post–World War II aerial view of North Head, radio station buildings and antennae and weather station buildings have been removed. The 1898 keepers' quarters and barn are in the foreground, the lighthouse in the background. The footpath between the keepers' dwellings and lighthouse can be seen just to the left of the center of the photograph. (Courtesy of Pacific Alaska Region, National Archives and Records Administration.)

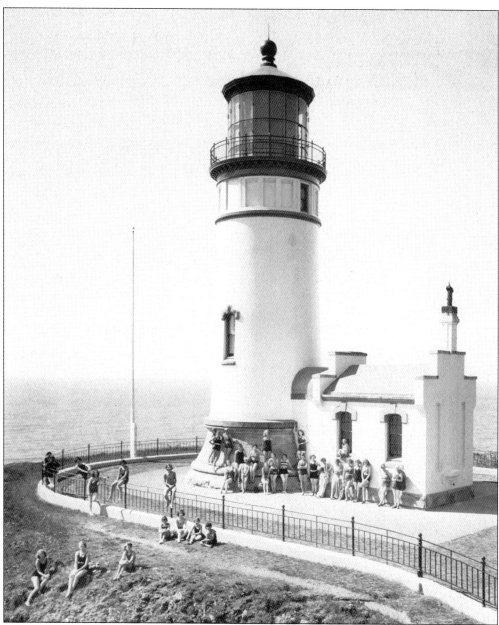

The girls at lower left, sitting at cliff's edge in this undated photograph of North Head Lighthouse, probably did not know that in 1923 second assistant keeper Frank C. Hammond had to recover "at great personal risk" the body of a keeper's wife who fell to her death from the precipice on which they posed. (Courtesy of Columbia Pacific Heritage Museum.)

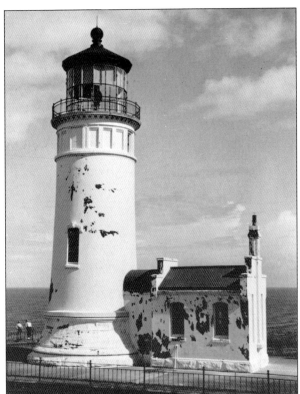

Paint-peeling storms have been known to strike North Head. The sun is shining here, and visitors beyond the lighthouse are looking over at surf breaking on the rocks below. Despite the sun and serenity, the scarred walls of the tower and workroom testify to the violence of a past storm. (Courtesy of Museum of History and Industry, Seattle.)

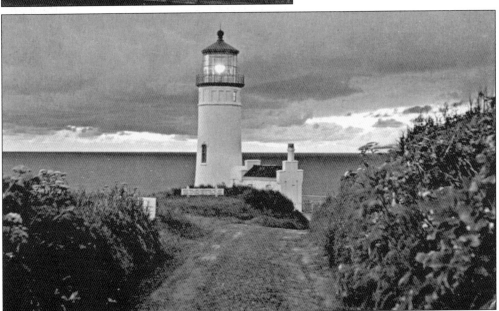

This postcard view of North Head Lighthouse shows the lens illuminated in the lantern of the 65-foot tower. In 1935, a fourth-order lens replaced a first-order Fresnel lens first exhibited on May 16, 1898. The first-order lens, which had earlier been at Cape Disappointment Light, was later displayed at Fort Canby State Park, and then at the Lewis and Clark Discovery Center. (Courtesy of Columbia River Maritime Museum.)

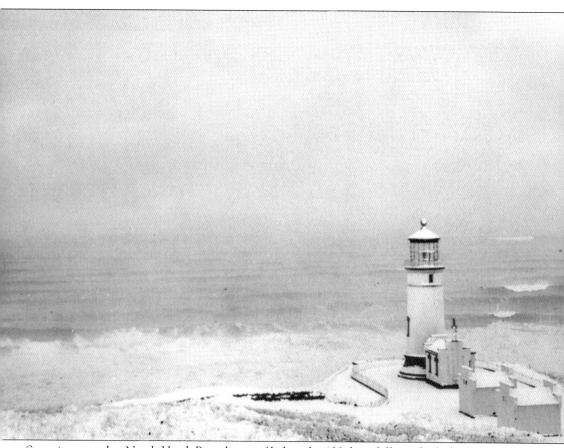

Snow is unusual at North Head. Pounding surf below the 130-foot cliff on which the lighthouse sits is not, and neither is the poor visibility suggested by the low clouds hanging over the ocean in the background. (Courtesy of Columbia River Maritime Museum.)

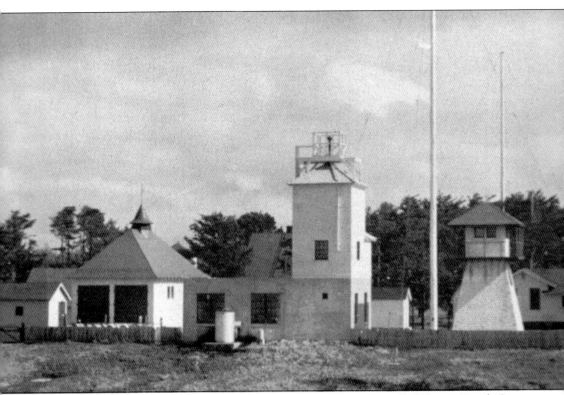

In 1891–1892, the Life-Saving Service constructed a new post, called Ilwaco Beach Station, about 14 miles north of the one at Cape Disappointment, on the Long Beach Peninsula. The station's boathouse is to the left and its watchtower to the right. The keeper's dwelling is in the background. (Courtesy of Columbia Pacific Heritage Museum.)

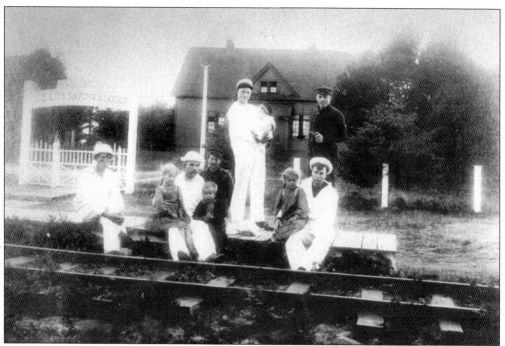
The Ilwaco keeper, plus some of his surfmen and their children, poses by tracks of the Ilwaco Railroad, which ran up the peninsula. When needed, the railroad would put on special trains to carry lifesavers from both Cape Disappointment and the Ilwaco station closer to shipwreck sites. (Courtesy of Pacific County Historical Society.)

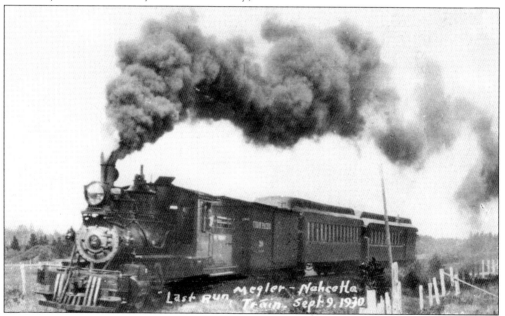
The Ilwaco Railroad, shown here making its last run on September 9, 1930, did help lifesavers get closer to shipwreck sites. It also caused them some problems. On August 13, 1902, sparks from an Ilwaco locomotive started a forest fire that the lifesaving station crew had to fight for several hours before putting it out. (Courtesy of Columbia Pacific Heritage Museum.)

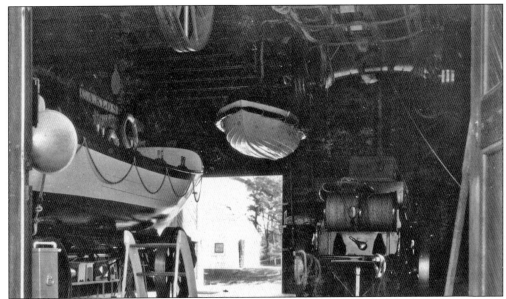

This is the interior of the Klipsan Beach boathouse. The station's lifeboat is to the left on a cart. The station's life car is to the right, hanging next to a beach cart. A name board from the schooner C. A. *Klose* hangs above the lifeboat. On April 19, 1905, the Klipsan crew used the lifeboat to take off workers salvaging the ship's cargo after the *Klose* stranded offshore. (Courtesy of Columbia Pacific Heritage Museum.)

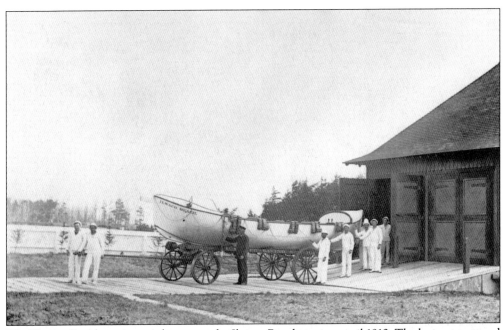

The Klipsan Beach station was known as the Ilwaco Beach station until 1912. The keeper proposed the change to the district office because Capt. A. T. Stream, a retired shipmaster, was developing a new town site with that name near the station. Here the lifeboat on its cart and its crew are outside the boathouse. The lifeboat bears the name "Ilwaco Beach" on its bow. (Courtesy of Pacific County Historical Society.)

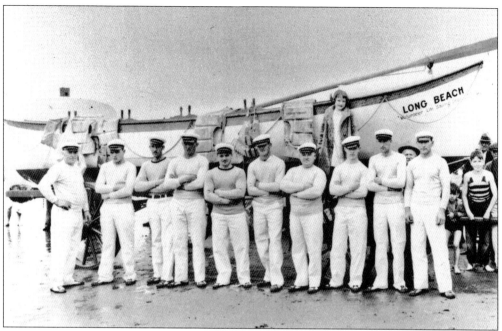

As if the name change from Ilwaco Beach to Klipsan Beach was not confusing enough, from about 1930 to 1934, the chamber of commerce in Long Beach, a community north of Ilwaco and south of Klipsan Beach, organized and funded its own lifesaving crew. (Courtesy of Columbia Pacific Heritage Museum.)

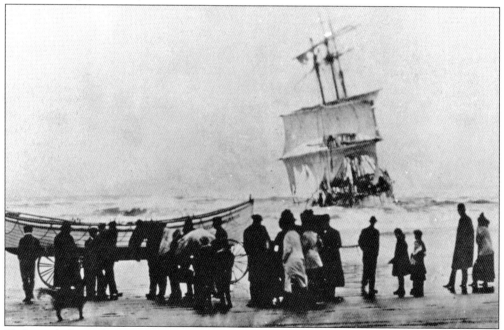

High winds drove the French ship *Alice*, carrying 3,000 tons of cement, ashore near Klipsan Beach on January 15, 1909. Spectators watched as the lifesaving crew prepared to launch its surfboat for an effort to rescue the crew. By the time they launched, *Alice*'s crew had come ashore in the ship's own boats. (Courtesy of Coast Guard Museum Northwest.)

Local residents welcomed the *Alice*'s crew members. They stayed in a hotel at Ocean Park, just up the beach from the Klipsan Beach Life-Saving Station. They posed holding the French tricolor for at least one photographer. (Courtesy of Coast Guard Museum Northwest.)

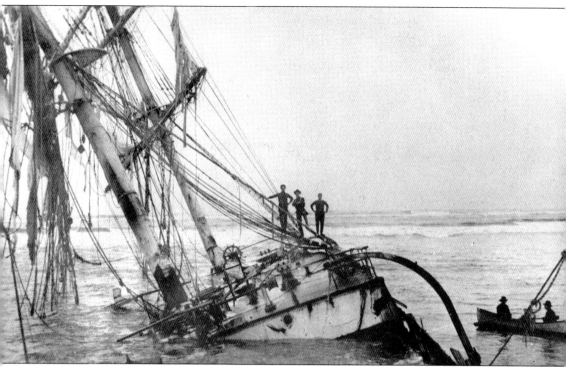

The cement in *Alice*'s hold hardened, settled, and held one of her masts upright. Traces of the wreck remained visible until 1930 and served as an attraction for visitors to the Long Beach Peninsula. Some actually toured the wreck. (Courtesy of Coast Guard Museum Northwest.)

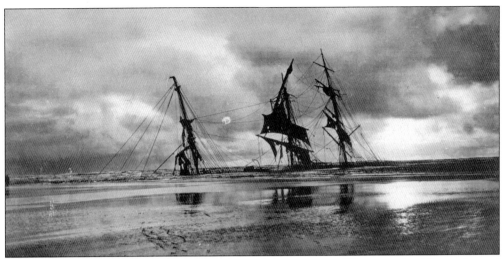

Eventually submerged almost completely so that only her masts could be seen, the *Alice* enchanted visitors and photographers for nearly 20 years before disappearing completely in 1930. (Courtesy of Pacific County Historical Society.)

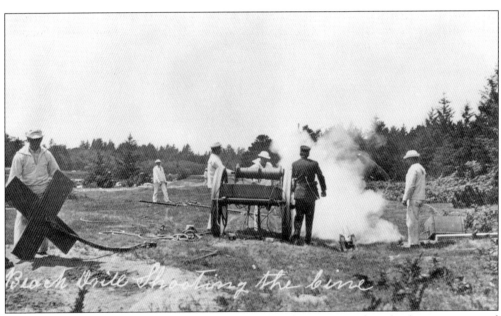

The Klipsan Beach crew's weekly drills with its beach apparatus drew both spectators and photographers. The Lyle gun, located in this photograph to the right of the beach cart between the keeper and a surfman, is firing a lead line to a practice tower obscured by the gun's smoke. The tower simulated a ship's mast, to which the lead line could be affixed. (Courtesy of Pacific County Historical Society.)

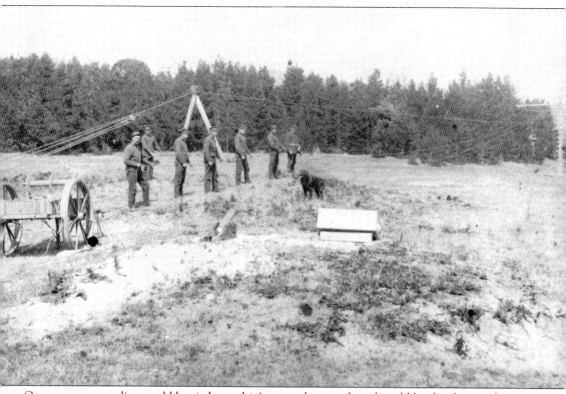

Once a messenger line could be tied to a ship's mast, those on board could haul in heavier lines from the beach that could be used to rig a breeches buoy apparatus. In this drill, a surfman pretending to be a survivor is at far right suspended in a breeches buoy and being hauled "ashore." (Courtesy of Pacific County Historical Society.)

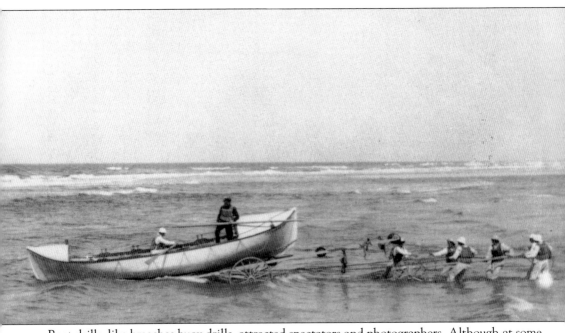

Boat drills, like breeches buoy drills, attracted spectators and photographers. Although at some stations lifeboats could be launched via ramps running directly from boathouses into the water, at Klipsan Beach, a horse-drawn cart was used to take the lifeboat across to the water's edge. (Courtesy of Pacific County Historical Society.)

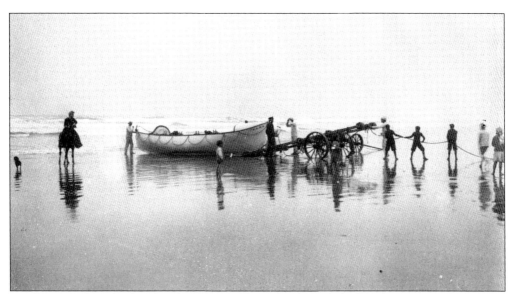

Small boys, judging by their knickers, seem to have decided to help the Klipsan Beach keeper and surfmen recover their boat as an even smaller child, beach-riding horsewoman, and dog look on. The Ilwaco Railroad stopped at least once a week to allow tourists to watch the station's drills. (Courtesy of Columbia River Maritime Museum.)

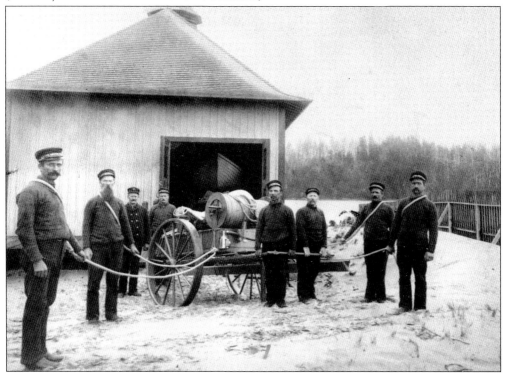

The Klipsan Beach crew stands in front of their boathouse with the station's loaded beach cart. The sand at their feet suggests how hard it must have been to haul the cart across the beach loaded down with many fathoms of line, one or two Lyle guns, breeches buoy, and hand tools. (Courtesy of Coast Guard Museum Northwest.)

The Klipsan Beach Life-Saving Station continued in use until after World War II. In the postwar era, the property was sold and subdivided into vacation lots with the buildings still standing. (Courtesy of Coast Guard Museum Northwest.)

Two
WILLAPA BAY TO GRAYS HARBOR

Shoalwater Bay, later known as Willapa Bay, is a shallow indentation on Washington's outer coast that reaches south almost to the Columbia River and north almost to Grays Harbor. Grays Harbor, about 10 miles north of Shoalwater Bay, is 15 miles deep and covers a 98-square-mile area. It receives five rivers flowing out of the Olympia Peninsula's mountains.

Shoalwater Bay has been important in maritime history for its fisheries and its role in the lumber trade. Its most interesting theme, however, is what happened to its lighthouse and its lifesaving station, both of which dated from the latter part of the 19th century but did not survive the 20th century.

Grays Harbor may exceed Shoalwater Bay in historical importance. The harbor's shores were first settled by Euro-Americans in the mid-19th century. Thereafter, it rapidly grew into the most significant port on Washington's outer coast.

Sailing along that coast in 1792, seagoing fur trader Robert Gray gave what became Grays Harbor its first name, Bulfinch Harbor, to honor one of his owners. Shortly afterward, a Royal Navy explorer renamed it in honor of Gray. About 50 years later, a U.S. Navy explorer said it "is the only harbor of importance south of Cape Flattery, at the entrance of the Strait of Juan de Fuca, and above the mouth of the Columbia. This has a narrow opening, however, with dangerous breaks on either side." This early assessment identified Grays Harbor's two fundamental characteristics as a port: its potential as a harbor and that harbor's navigation hazards.

That potential was well developed 50 years later. By 1890, Grays Harbor had 13 sawmills that exported 60 million board feet of lumber, all of it by ship. By 1905, Grays Harbor claimed to be the largest lumber shipping port in the world. Logs arrived at the harbor's many mills bundled in rafts floated down the rivers feeding into the harbor and—as roads improved—on fleets of huge logging trucks. Half of all spruce cut for America's World War I effort came from harbor mills. In 1923, those mills cut a record 1,128,750,000 board feet of lumber. The harbor's lumber shipments, which went all over the world, exceeded those of all of America's other coastal ports.

Timber remained important cargo for its ships, but Grays Harbor diversified its maritime commerce as the 20th century progressed. By the 1930s, some 200 commercial fishing boats went out from the harbor. In 1947, one thousand boats based at Grays Harbor brought in 10,000 tons of tuna. Twenty years later, over 250 sport fishing charter boats operated out of Westport, the small town where a lighthouse and a lifesaving station had opened in 1898.

Grays Harbor's lighthouse and lifesaving station were established close to 18 miles of sandy but dangerous beaches stretching south to Shoalwater Bay. Photographers frequently documented both.

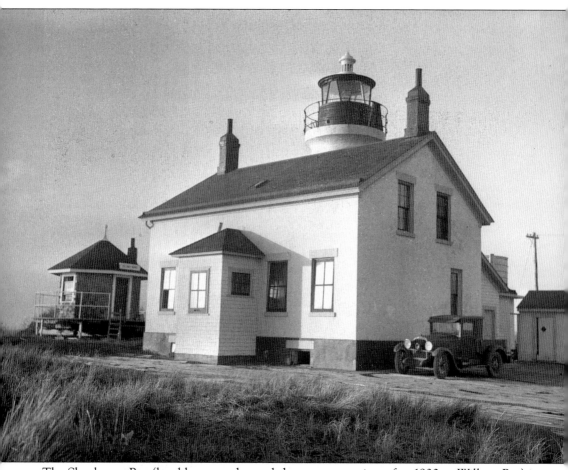

The Shoalwater Bay (local boosters changed the name sometime after 1900 to Willapa Bay) is pictured on November 17, 1940. The 1858 vintage lighthouse would survive for only a few weeks after this picture was made. (Courtesy of Jones Historical Photo Collection.)

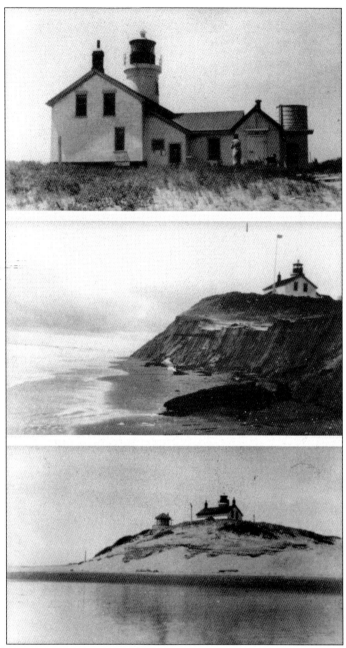

In August 1854, Congress appropriated funds for a lighthouse on what was then known as Shoalwater Bay. Authorities selected a lighthouse site on the northern side of the bay's entrance, on Cape Shoalwater high above the bay. District officials staged some construction supplies and oxen to haul them to Shoalwater Bay at Cape Disappointment in 1856. Other materials came direct by sailing ship. Plans called for a lighthouse typical of other West Coast beacons on a high promontory, that is, a short tower incorporated into a keeper's dwelling. Hartman Bache, a district engineer at San Francisco, probably designed the lighthouse. The first keeper, a Captain Wells, and assistant keeper Daniel Wilson turned Shoalwater's fourth-order beacon on for the first time on October 1, 1858. (Courtesy of Pacific County Historical Society.)

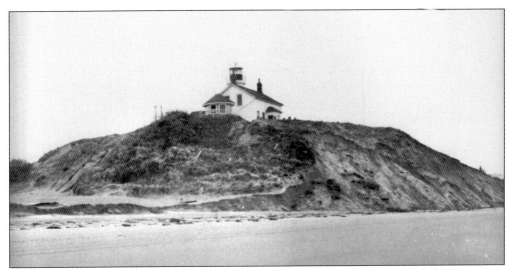

Cape Shoalwater's masonry tower and the lantern capping it rose 42 feet from the center of the keeper's dwelling. A lookout building was built adjacent to the lighthouse. The light operated for less than a year and was not exhibited again until 1861 with a new keeper, Robert H. Espy. (Courtesy of Pacific County Historical Society.)

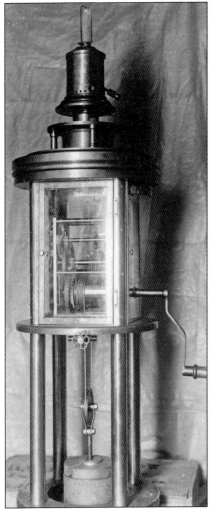

A clockwork mechanism enabled the Cape Shoalwater oil lamp's rotation in the early years. A series of cogs and gears attached to a weight enabled the weight to descend slowly. The energy generated by the descent rotated the lamp. (Courtesy of Pacific County Historical Society.)

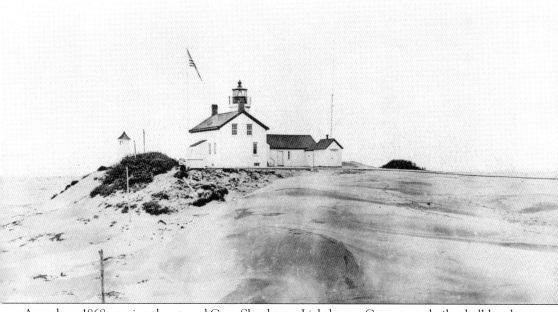

As early as 1868, erosion threatened Cape Shoalwater Lighthouse. Contractors built a bulkhead to protect the foundation, and 2,000 square feet of planking was laid to cut down on sand blowing into the lighthouse. In 1869, keepers planted bushes to diminish erosion. The edge of the planking can be seen in this early-20th-century view of the landward side of the lighthouse. (Courtesy of Coast Guard Museum Northwest.)

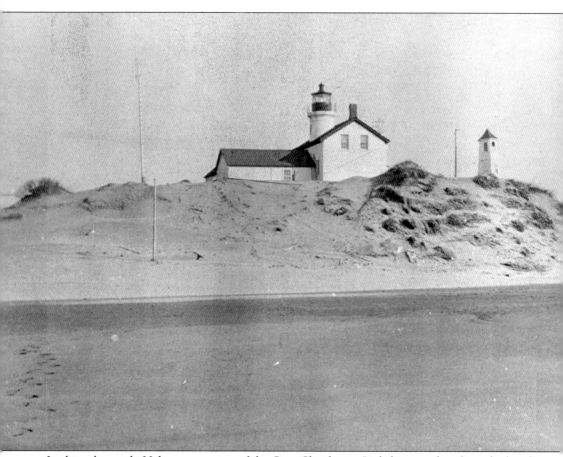

In this other early-20th-century view of the Cape Shoalwater Lighthouse, taken from the beach below, the cape seems to have shrunk considerably. Despite fences, brush mats, and newly planted trees, the cape retreated 50 to 100 feet each year. The lookout tower seems to have had its height increased as the cape lowered. (Courtesy of Coast Guard Museum Northwest.)

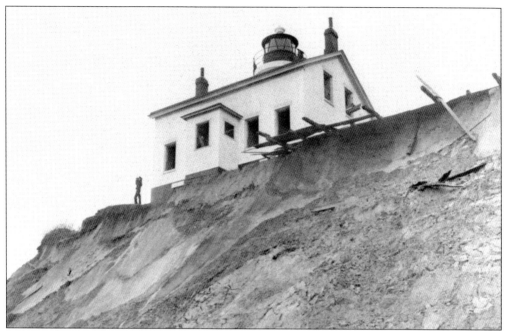

By 1940, the situation at Cape Shoalwater was grave. The Coast Guard removed the Fresnel lens and other fittings. The lighthouse teetered on the edge of the eroded cape. A Coast Guardsman, far left, is on lookout. By this time, the lighthouse windows had been salvaged. (Courtesy of Pacific County Historical Society.)

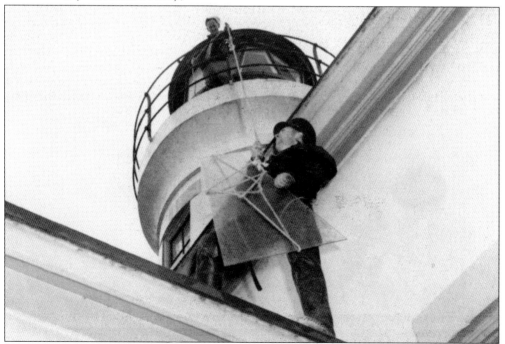

Coast Guardsmen removed not only the windows in the lower part of the lighthouse, but also panes in the lantern. Some were probably recycled to be used in another lighthouse. The fate of the Shoalwater lens is unclear. (Courtesy of Pacific County Historical Society.)

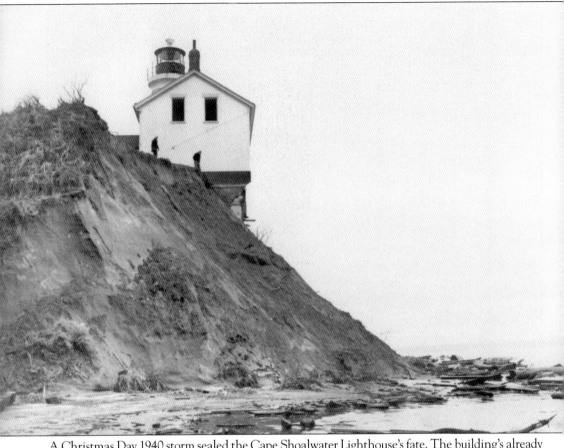
A Christmas Day 1940 storm sealed the Cape Shoalwater Lighthouse's fate. The building's already precarious position deteriorated. On December 26, its south wall collapsed and the lighthouse fell into the water below. (Courtesy of Pacific County Historical Society.)

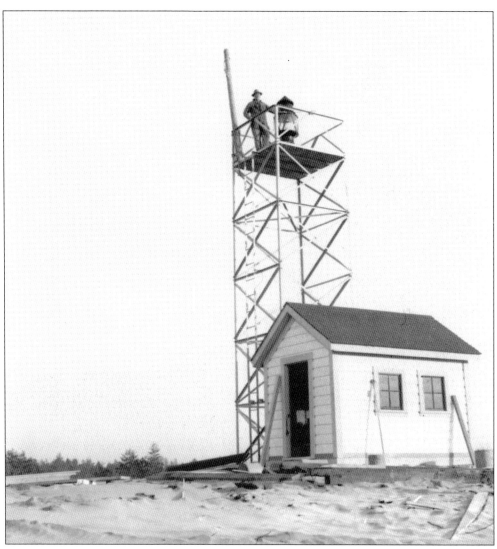

In the years after 1940, the Coast Guard erected a series of steel tower-mounted beacons on Cape Shoalwater. As the cape continued to erode, the beacons were moved farther inland. The U.S. Lighthouse Society's Web site, at http://uslhs.org/lighthouse_characteristics/maps/washington/willapa_bay_light_map.htm, has a map showing the retreat of the cape over the years. (Courtesy of Pacific County Historical Society.)

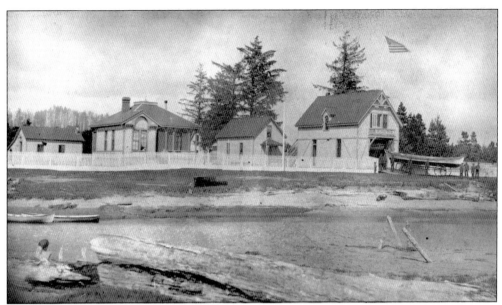

The U.S. Life-Saving Service proved just as unfortunate as had the Lighthouse Service in choosing a Shoalwater Bay station site. After Congress authorized staffed lifesaving stations on the Pacific Coast in 1874, lifesaving officials built a station inside Cape Shoalwater in sheltered water known as North Cove. (Courtesy of Coast Guard Museum Northwest.)

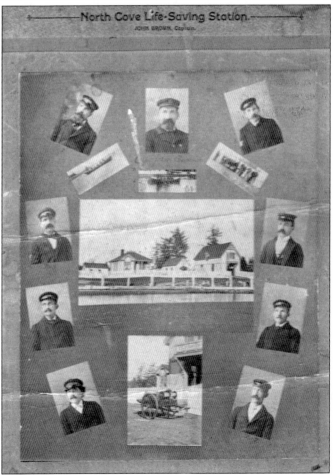

This montage, created about 1897, includes the North Cove crew. From top left and clockwise around the display, they are Hans Henson, Capt. John Brown, unidentified, James Smith, Nels Hanson, Adolph Holtz, Anton Anderson, ? Gunderson, and unidentified. The exhibit also shows the station's boats and buildings and, bottom center, its beach cart. (Courtesy of Westport Maritime Museum.)

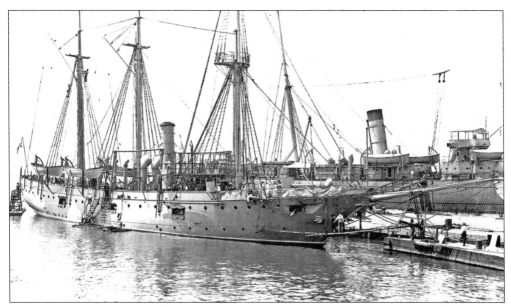

The North Cove Life-Saving Station's record was similar to that of many other stations: beach patrols, inaugurated in 1880–1881, rescue of ships and boats in distress, and general assistance to nearby communities. One unusual incident occurred on November 29–30, 1909, when the USS *Princeton* stranded on Cape Shoalwater's North Spit. Surfmen went to South Bend, 15 miles south, for a tug, and then the station's lifeboat ran a hawser from the tug to the gunboat so she could be towed into a safe harbor. (Courtesy of Naval Historical Foundation.)

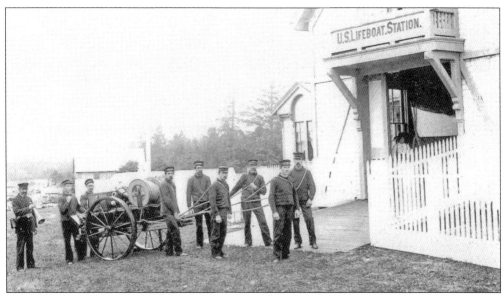

Captain Brown, equipped with megaphone for directing his crew, and the crew hitched to North Cove's beach cart. The cart carries a Lyle gun, faking box for the gun's lead line, a breeches buoy apparatus, and heavier line for rigging the breeches buoy. (Courtesy of Coast Guard Museum Northwest.)

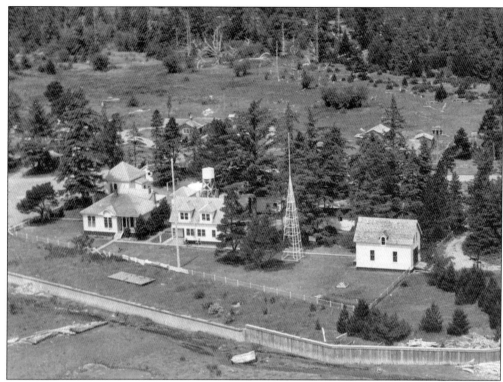

It took another 20 years, but erosion at Cape Shoalwater threatened the North Cove Lifeboat Station just as it had the nearby lighthouse. As this 1947 aerial view shows, despite a low seawall, the ocean came closer. (Courtesy of Pacific Alaska Region, National Archives and Records Administration.)

By the mid-1950s, it was clear the land on which the North Cove station sat would soon be washed away. The station's buildings were boarded up. The Coast Guard built a new station farther inside the bay at Tokeland for a cost of $79,000 and moved the station there in 1956. (Courtesy of Coast Guard Museum Northwest.)

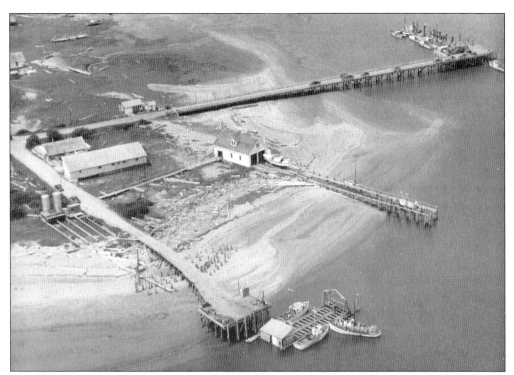

The Tokeland boathouse was down the road from the station's other buildings. In this aerial view, the station's 36-foot lifeboat can be seen on the ways leading from the boathouse down to the water. (Courtesy of Pacific Alaska Region, National Archives and Records Administration.)

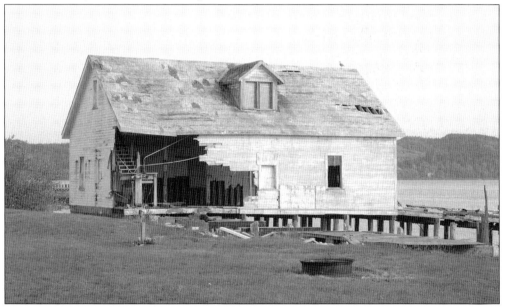

In 1978, the Tokeland lifeboat station closed and its personnel were reassigned to the Coast Guard facility at Westport on Grays Harbor to the north. The government sold station buildings to private owners. In December 2007, a severe winter storm swept away the Tokeland boathouse, which was already falling apart. (Author's collection.)

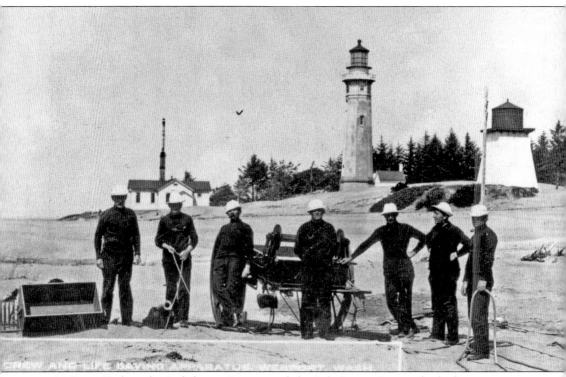

At Grays Harbor, the Lighthouse Service and the Life-Saving Service built their stations near each other and almost simultaneously in 1897–1898. Here the crew from what was then known as the Petersons Point Life-Saving Station poses with, from left to right, the foghorn building, lighthouse, oil houses, and water tower of Grays Harbor Light Station in the background. (Courtesy of Polson Museum.)

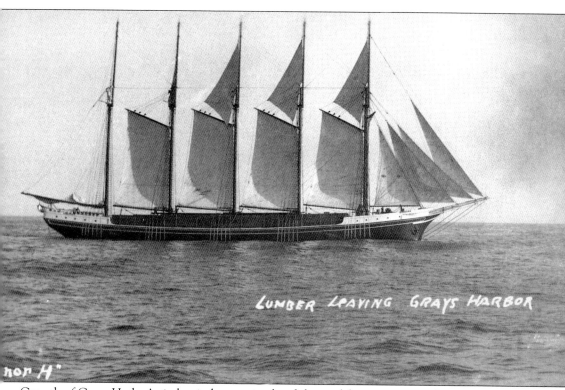

Growth of Grays Harbor's timber industry stimulated demand for navigation aids to assist ships arriving to carry lumber to ports all over the world. In 1890, the harbor's 13 sawmills exported 60 million board feet of lumber on over 250 outbound vessels. The sailing schooner *Elinor H.* is leaving Grays Harbor with lumber stacked on her deck. (Courtesy of Washington State Historical Society, Tacoma.)

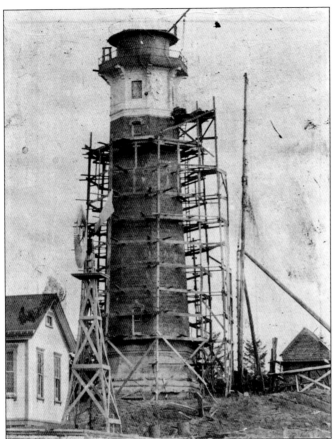

Engineers surveyed the site for Grays Harbor Light in 1895. Architect C. W. Leick completed plans for the light station in 1896. Construction began in 1897. (Courtesy of Westport Maritime Museum.)

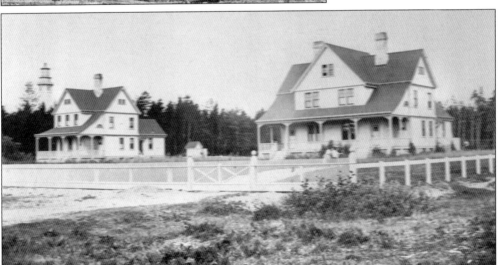

As lighthouse construction proceeded, workers cleared and filled a swampy tract, below the dune on which the lighthouse would sit, for lighthouse keepers' quarters. A single-family residence was built for the head keeper and a duplex provided for assistant keepers. Privies were placed behind each dwelling and a small barn built at the northern end of the tract. (Courtesy of Westport Maritime Museum.)

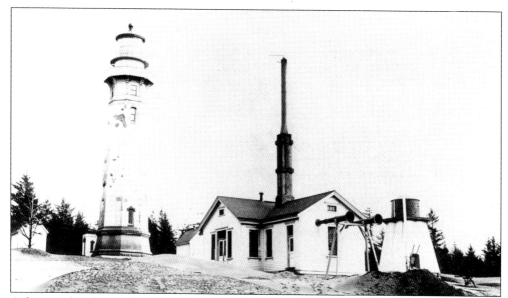

A fog signal with twin horns operated immediately in front of, or to the west of, Grays Harbor Lighthouse. Oil houses sat to either side of it. A 60-by-90-foot timber bulkhead protected the fog signal building from sliding down the slope of the sand dune on which it and the lighthouse sat. Steam generated by a coal-fired boiler powered the signal's twin horns. (Courtesy of Coast Guard Museum Northwest.)

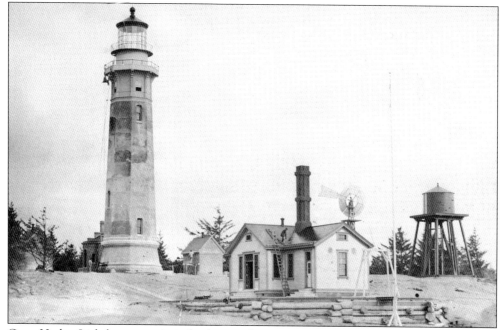

Grays Harbor Lighthouse was in its final stage of construction in the spring of 1898. The lens was not yet installed when this picture was taken. Architect Carl W. Leick designed 22 lighthouses in Washington, 7 in Oregon, and 11 in Alaska. Grays Harbor Lighthouse is regarded as his masterpiece. (Courtesy of Jones Historical Photo Collection.)

Beachgoers also visited the lighthouse. They arrived on paddle-wheel excursion boats from towns at the head of the harbor to swim and play in the surf, walk on the beach, and—according to Christian Zauner, the first keeper at Grays Harbor—track sand and moisture into the lighthouse. He advised against admitting visitors on foggy or rainy days because "too much moisture [is] carried up into the lens room." (Courtesy of Westport Maritime Museum.)

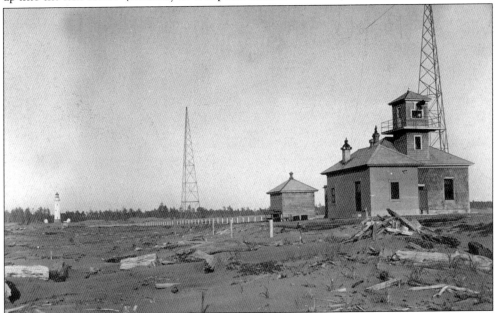

In 1916, the original fog signal building at Grays Harbor Light burned. In 1926, a new fog signal was established in a concrete fireproof structure about 2,100 feet west of the lighthouse. In the years since lighthouse construction, beach accretion resulted in the lighthouse being well away from the ocean. As the radio antenna towers in the picture indicate, a radio station had also been built at the light station after World War I. (Courtesy of Columbia River Maritime Museum.)

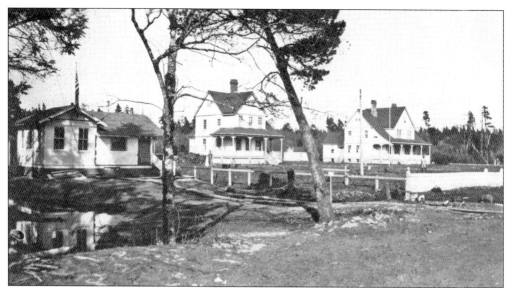

In 1920–1921, the U.S. Navy built and then turned over to the Coast Guard a radio direction-finding station adjacent to Grays Harbor Light Station. The one-story building at the far left of this picture was the original radio station office and quarters for radio operators. (Courtesy of Westport Maritime Museum.)

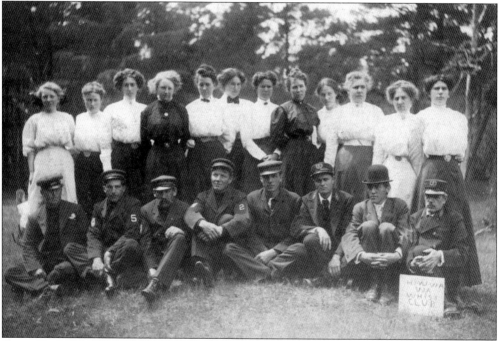

Grays Harbor Light Station's location directly across the street from the Grays Harbor Life-Saving Station (whose name changed from Petersons Point in 1906) allowed for mutual support and some socializing. People from both stations formed a whist club early on. Family members stand behind seated surfmen and light keepers. The first five men from the left belonged to the Life-Saving Service and the three on the end to the Lighthouse Service. (Courtesy of Westport Maritime Museum.)

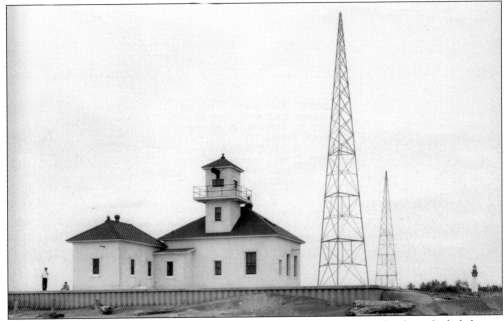

The 1926 fog signal building at Grays Harbor Light Station, although 2,100 feet from the lighthouse, was only about 400 feet from water's edge. A steel caisson was sunk into beach sands to protect the fog signal from storm surges. Even so, high tides frequently left the ground between the lighthouse and fog signal wet. An elevated walkway connected the two. (Courtesy of Westport Maritime Museum.)

Grays Harbor Lighthouse, already important to mariners, became an important symbol of the area's history as time passed. (Courtesy of Westport Maritime Museum.)

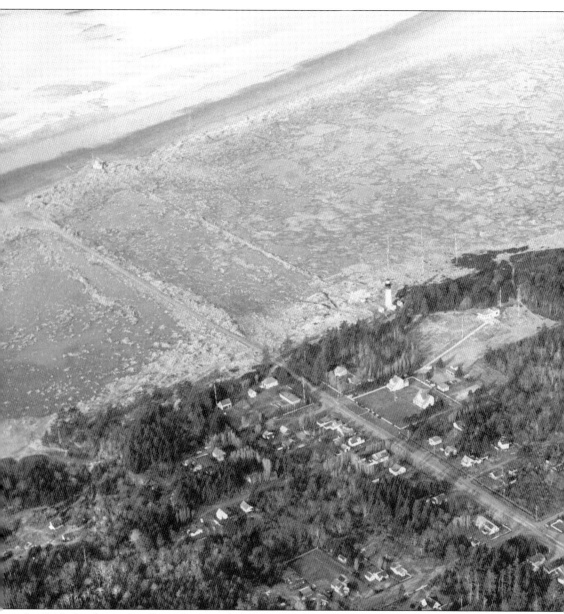

In 1946, the elevated walkway between lighthouse and fog signal building on the beach was torn down. The fog signal building itself was abandoned and left to wash away into the ocean. Radio antenna towers once between the lighthouse and fog signal building were relocated farther north. (Courtesy of Coast Guard Museum Northwest.)

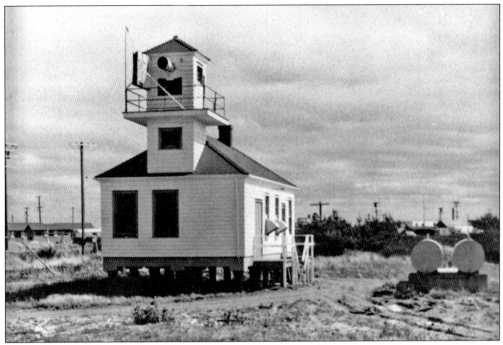

When the Coast Guard abandoned the fog signal building on the beach in front of Grays Harbor Lighthouse in 1946, it built a new, smaller fog signal building to the north near Grays Harbor's south jetty. (Courtesy of Coast Guard Museum Northwest.)

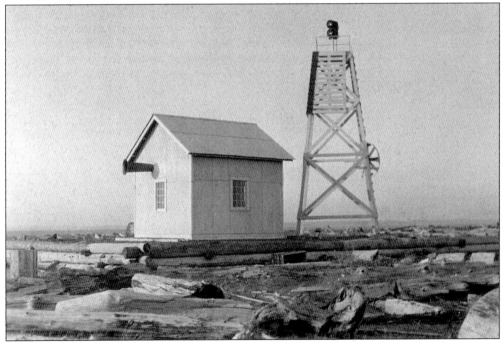

Since then, the fog signal has been relocated several times and is now on the jetty itself. Community residents differ as to whether the moaning of the foghorn for several hundred hours a year is a blessing or a sleep-disturbing annoyance. (Courtesy of Columbia River Maritime Museum.)

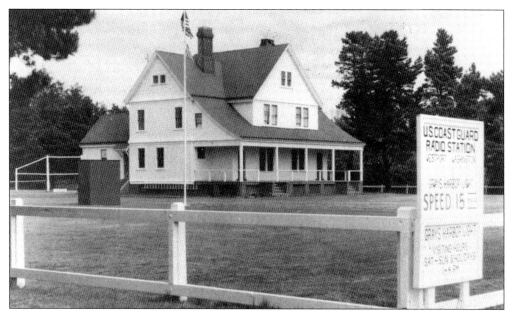

Coast Guard radio operations at Grays Harbor expanded during World War II. At the end of the war, the radio station took over the former keeper's and assistant keepers' dwellings. Coast Guard Radio Station Westport, call sign NMW, operated until 1973, when its Morse operations relocated to Point Reyes, California, and its voice operations to Astoria, Oregon. (Courtesy of Pacific County Historical Society.)

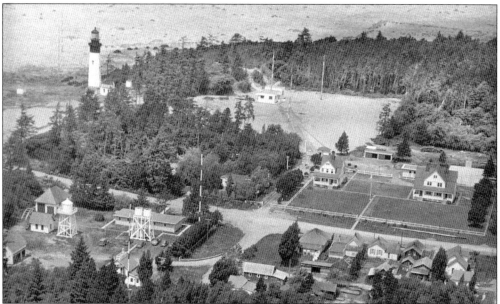

As this 1947 aerial view shows, Coast Guard radio operations preempted most of the light station's grounds and buildings. The former lighthouse keeper's quarters housed the radio station's commanding officer, and the former assistant keepers' duplex housed other Coast Guard personnel. A new radio operations building is at top center, and the lighthouse with attached workroom and flanking oil houses is at top left. (Courtesy of Pacific Alaska Region, National Archives and Records Administration.)

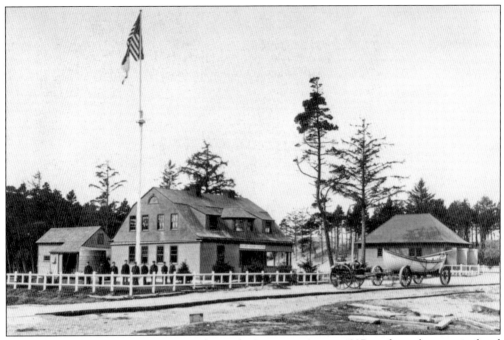

When construction began on Grays Harbor Light Station in August 1897, work was being completed on what was then called the Petersons Point Life-Saving Station. The station was on the other side of the street leading to the beach, below the inland side of the dune on which the lighthouse sat. It included a boathouse, a station building, and a small barn. The station's beach cart and surfboat with its wagon are in front of the dwelling in this picture. (Courtesy of Polson Museum.)

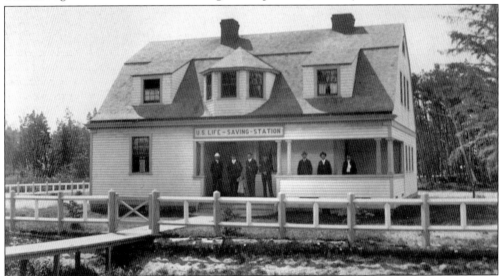

The lifesaving station dwelling at Petersons Point had a crew's reading/sitting room, kitchen/dining room, and washroom on the ground floor to the left of the central entrance and crew's quarters on the second floor over those spaces. To the right of the entrance was the station office. A separate kitchen/dining room and pantry for the keeper and his family were behind the office with two bedrooms for the keeper's use on the second floor. A single staircase at the end of the entrance hall led to the second floor. (Courtesy of Westport Maritime Museum.)

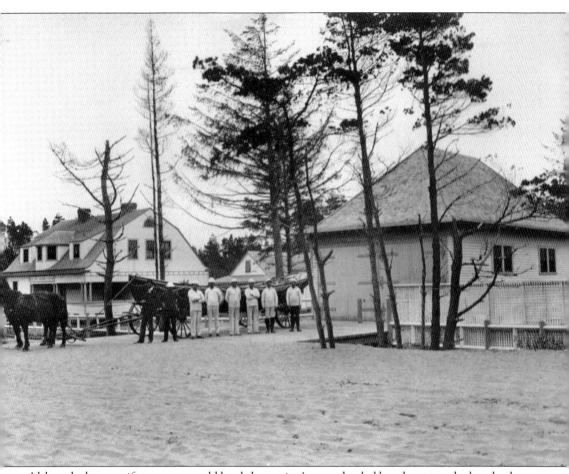

Although the crew if necessary could haul the station's two-wheeled beach cart to the beach, the four-wheeled wagon with the heavy surfboat had to be horse-drawn. Surfmen, keeper, and horse pose here with the surfboat and wagon in front of the station's boathouse. The boathouse is to the right, the station building to the left, and the barn in the center background. (Courtesy of Westport Maritime Museum.)

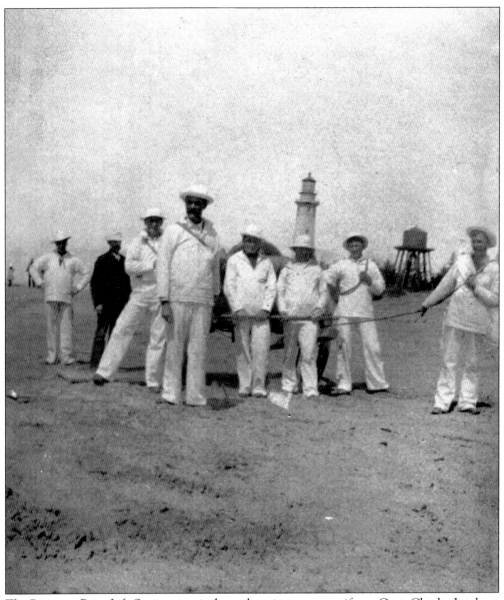

The Petersons Point Life-Saving crew is shown here in summer uniform. Capt. Charles Jacobsen is second from left in the back. Captain Jacobsen commanded the station from 1897 to 1917 and was followed in command by his son, Roy. (Courtesy of Westport Maritime Museum.)

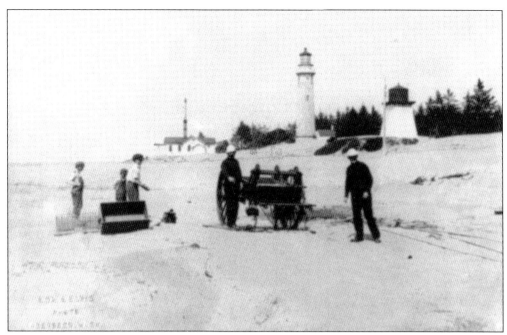

Poses with the light station in the background were photographers' favorite. The light station's water tower, lighthouse, and fog signal building are in the background. Keeper Jacobsen and surfman Mattis Persson are in the midst of a drill, as three boys watch. On the ground, from left to right, are the pegged board, faking box, Lyle gun, and beach cart. Heavier lines for the breeches buoy are on the ground to the right of Jacobsen. (Courtesy of Westport Maritime Museum.)

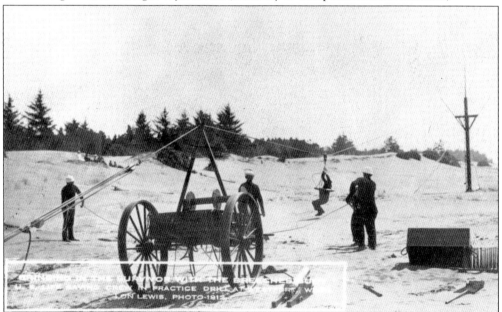

In this view, photographer Lon Lewis has gone around the drilling lifesavers to take a picture of the breeches buoy strung between one end anchored in the sand and the other secured to a practice pole that simulated a ship's mast. Lifesaving crews practice this routine at least once a week. (Courtesy of Polson Museum.)

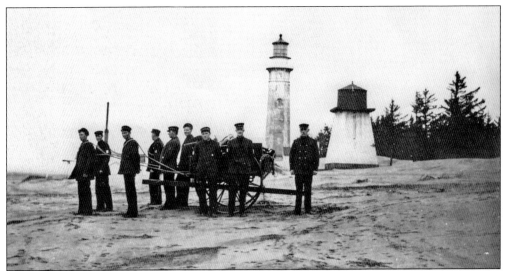

Keeper Jacobsen is seen with his complete crew hitched to the station's beach cart. Each surfman's sleeve bore a number indicating his place in the crew and duties in carrying out particular operations, such as rigging a breeches buoy or launching a surfboat. The lighthouse is still stone colored, suggesting that this picture was taken sometime between 1898 and 1901. After 1901, the masonry part of the lighthouse was painted white. (Courtesy of Coast Guard Museum Northwest.)

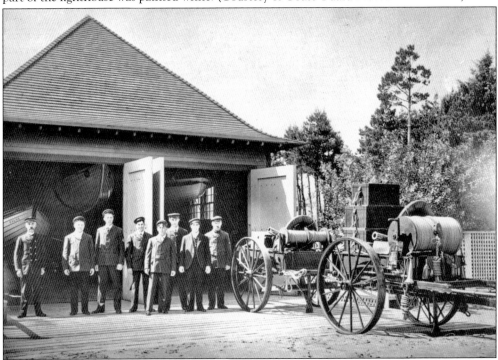

After 1906, what had been called the Petersons Point Life-Saving Station was known as the Grays Harbor Life-Saving Station. Here the station's keeper and crew are in front of the boathouse, with its boats inside. To the right and in front of the crew are the station's beach cart and a heavier wagon for the surfboat or lifeboat. The wagon could carry a boat and other lifesaving apparatus at the same time. (Courtesy of Westport Maritime Museum.)

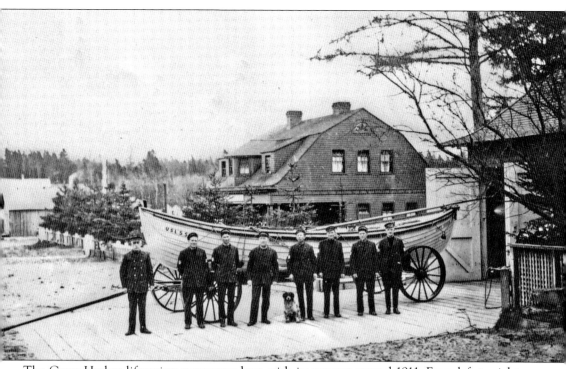

The Grays Harbor lifesaving crew poses here with its mascot around 1911. From left to right are Charles Jacobsen, Albert "Dandy" Franks, Hilman Persson, Jack Kelly, Martin Rasmussen, Charles Walker, Marcus Jacobsen (son of Charles), and Mattis Persson. Life-Saving Service architect Victor Mendleheff designed the station building in the background. The building was the prototype for what became known as "Petersons Point" stations. (Courtesy of Coast Guard Museum Northwest.)

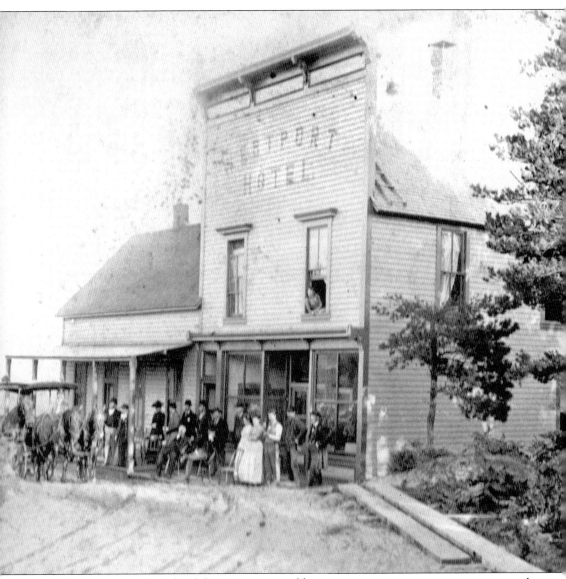

Although the Grays Harbor lifesaving crew would participate in many maritime rescues, it also assisted in the community. In a February 15, 1901, letter, C. W. Yana and his wife, owners of the Westport Hotel, shown here, wrote, "Dear Captain [Jacobsen]: We don't know how to thank you and your faithful crew for your services in saving our property (the Westport Hotel) from destruction by fire on the 9th inst. We might have had a big loss. It shows what discipline is in the time of danger. Again, we thank you and your crew." (Courtesy of Westport Maritime Museum.)

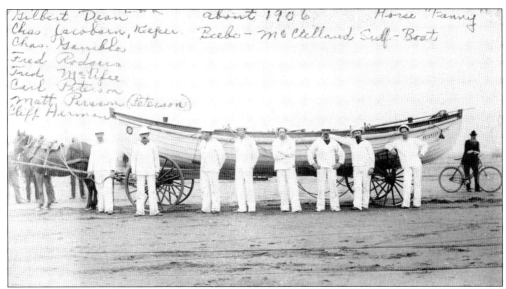

When the station's surfboat was needed, a team of horses pulled boat and wagon along the beach to a point where the boat could be launched. Here the crew poses in 1906 with its Beebe-McClellan surfboat; from left to right are Gilbert Dean, Charles Jacobsen, Charles Gamble, Fred Rodgers, Fred McAfee, Carl Peterson, Mattis Persson, and Cliff Herman. The horse is Fanny. (Courtesy of Westport Maritime Museum.)

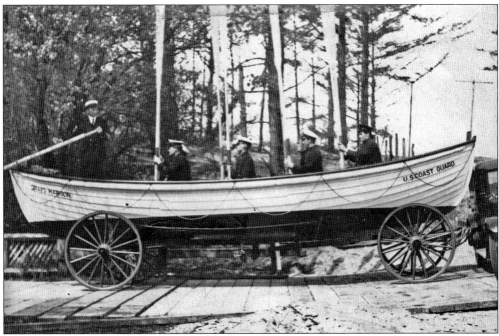

Lifesaving crews were apparently a photographer's dream, interesting subjects who could be persuaded to pose. Here, sometime after 1915, when they donned Coast Guard uniforms, the Grays Harbor crew demonstrates "tossed oars." The man at the tiller is probably Charles Jacobsen's son, Roy, his successor. (Courtesy of Westport Maritime Museum.)

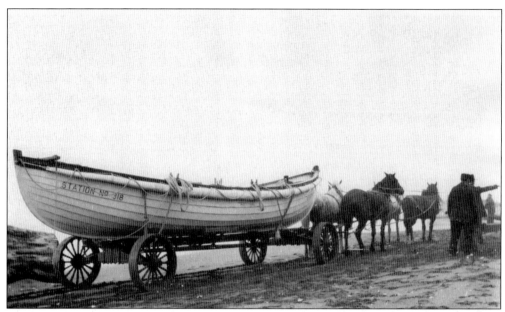

Although occasionally taking time to accommodate photographers, the lifesavers put in full, hard days. Shepherding heavy boats through beach sands was arduous, often followed by the difficult task of launching a boat through the surf when a wreck site was reached. The large log to the left suggests that travel down the beach faced many obstacles. (Courtesy of Westport Maritime Museum.)

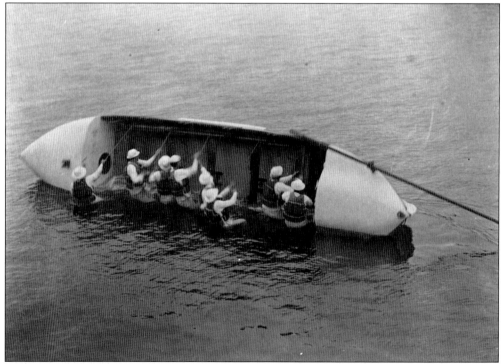

The Grays Harbor crew, as did crews at other stations, practiced capsizing and then righting their craft. At Grays Harbor, practices could be carried out in the calmer waters of the harbor or in the rougher ocean outside the harbor. (Courtesy of Westport Maritime Museum.)

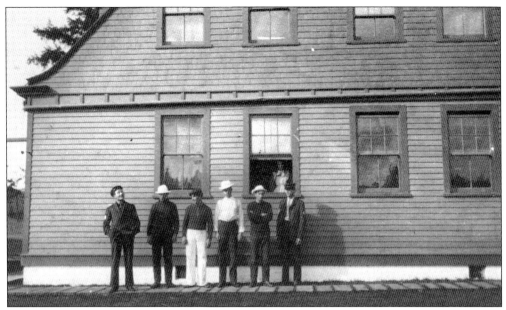

The lifesaving crews posed both formally and informally, although the latter was rare. This shows what is probably the keeper's quarters side of the lifesaving station at Grays Harbor. The woman in the window behind the men is probably the keeper's wife. (Courtesy of Westport Maritime Museum.)

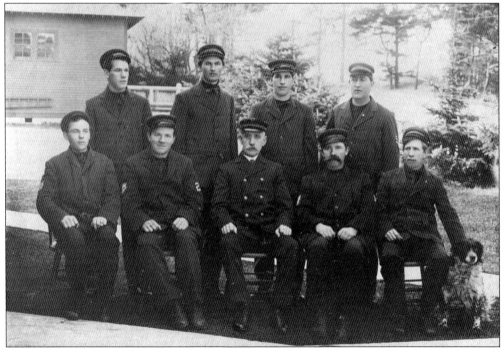

Not everyone in this 1912 picture has been identified. From left to right are (first row) unidentified, Albert "Dandy" Franks, Capt. Charles Jacobsen, Martin Rasmussen, unidentified, and an unidentified mascot; (second row) ? Greenbrook, Hilman Persson, an unidentified surfman, and surfman Jack Kelly. (Courtesy of Westport Maritime Museum.)

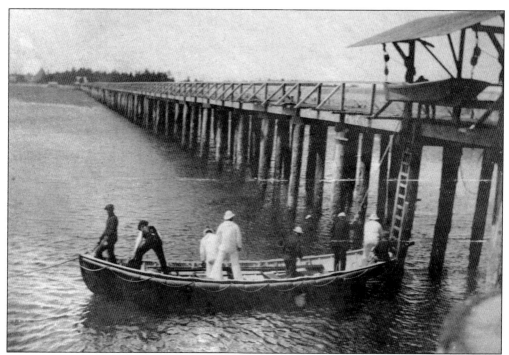

After the Grays Harbor Life-Saving Station received its first motorized boat in 1914, the station's lifeboat was docked inside Grays Harbor at the end of Westport's Pacific Avenue. When alerted, the crew crossed Chehalis Point by truck to reach the dock. (Courtesy of Westport Maritime Museum.)

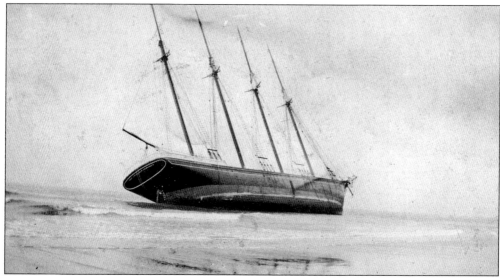

The *King Cyrus* was one of many vessels that ran into trouble at Grays Harbor. The 717-ton schooner was returning from Honolulu where she had delivered a cargo of lumber. She grounded on a sandbar at the harbor entrance on July 17, 1922, while being towed in by a tug and later broke apart off Westport after the crew was removed. Relics of the *King Cyrus* are displayed at the Westport Maritime Museum, which is housed in the 1940–1972 Grays Harbor Life Boat Station. (Courtesy of Westport Maritime Museum.)

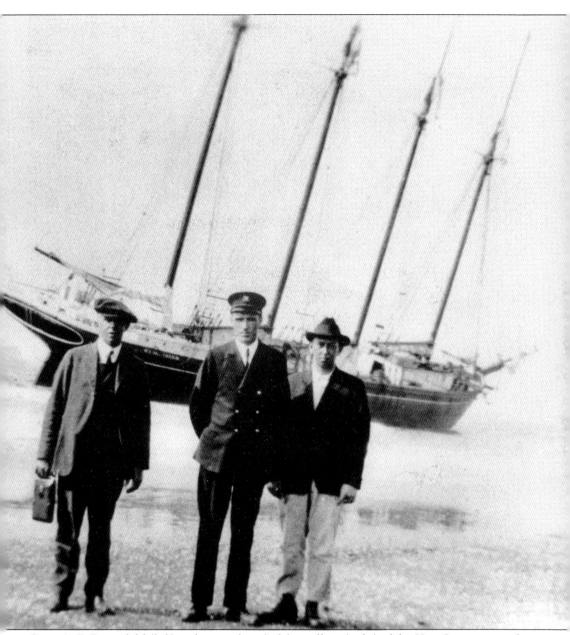

Capt. A. E. Rosendahl (left) and an unidentified first officer (right) of the *King Cyrus* pose with Oscar Hawthorne, officer-in-charge, at the Grays Harbor Life-Saving Station in front of the grounded vessel. Hilman Persson replaced Hawthorne when he died. Persson joined the lifesaving crew at age 18 in 1906 as a temporary surfman after emigrating from Sweden. Hired full-time in 1907, he transferred to Willapa (Shoalwater) Bay in 1919 as second-in-command. He returned to Grays Harbor as commanding officer in 1922 and remained there through 1938. (Courtesy of Westport Maritime Museum.)

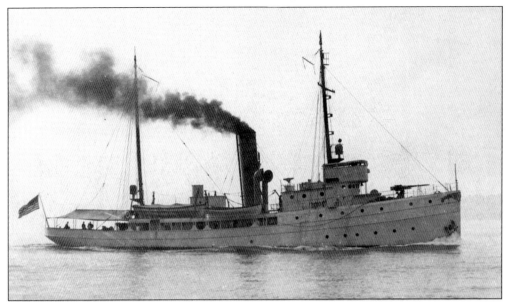

On November 24, 1927, gale-force winds drove the Japanese steamship *Tenpaisan Maru* ashore at Copalis Beach north of Grays Harbor. The Coast Guard's rescue tug *Snohomish*, shown here, arrived the next morning but could not come close enough to pull the ship off because of the shallow water. (Courtesy of Coast Guard Museum Northwest.)

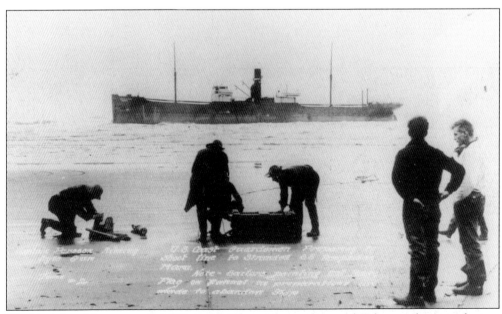

The *Tenpaisan Maru* grounded 200 yards offshore in pounding surf. Taken to the scene by tug, the Grays Harbor lifesaving crew rigged its breeches buoy on November 25. Here the lifesavers are getting ready to fire a lead line to the ship. Hundreds gathered to watch as the rescue progressed. (Courtesy of Westport Maritime Museum.)

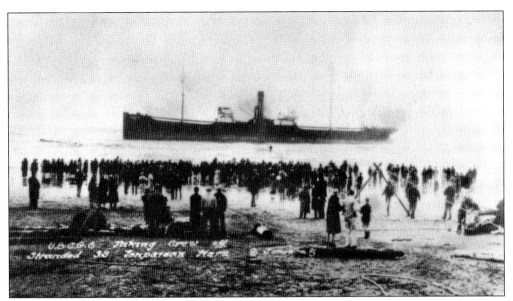

Once their breeches buoy apparatus was linked to the *Tenpaisan Maru*, the Grays Harbor team started taking off the freighter's captain and 46-person crew. Fascinated spectators stayed on the windy beach to watch rescue efforts. In this photograph, at center, one of the crew members is halfway between ship and shore. (Courtesy of Westport Maritime Museum.)

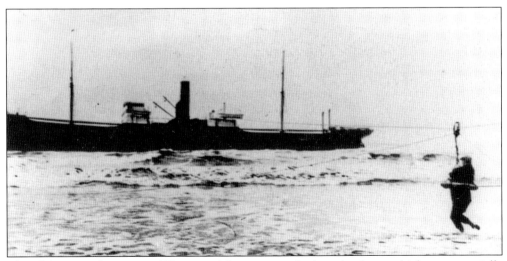

This closer view shows one of *Tenpaisan Maru* crew in the breeches buoy, which was essentially a life ring with canvas trousers attached, suspended below a line on which it could be hauled to shore. (Courtesy of Westport Maritime Museum.)

The Prohibition era brought additional duties for the lifesavers and light keepers at Grays Harbor. Because the Life-Saving Service had integrated with the Coast Guard in 1915, lifesaving crews backed up other Coast Guardsmen in enforcing the ban on alcohol sales in effect from 1920 to 1932. (Courtesy of Westport Maritime Museum.)

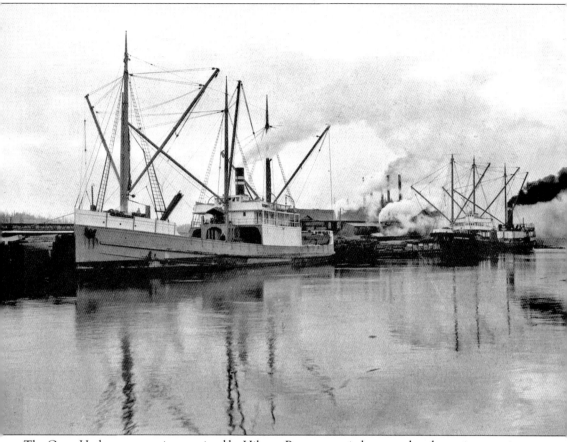

The Grays Harbor crew, again captained by Hilman Persson, carried out another dramatic rescue in 1937. The steam schooner *Trinidad* (left) departed Willapa Bay on May 7, was driven off course by high winds, and struck on the bay's North Spit. Personnel at the North Cove Life-Saving Station saw the *Trinidad*'s distress flares, but their lifeboat was out on another mission. The Coast Guard station at Grays Harbor sent its 36-foot motor lifeboat, which plowed through heavy seas and reached the wreck the next morning. Although the surrounding sea was covered with wreckage, the crew in the lifeboat was able to take off the *Trinidad*'s crew one or two at a time.

The Grays Harbor crew received Congressional gold lifesaving medals for their efforts. Persson (far right) later accepted the American Legion Medal for Valor on behalf of the entire crew. He retired in 1939 but returned to active duty during World War II. (Courtesy of Jones Historical Photo Collection.)

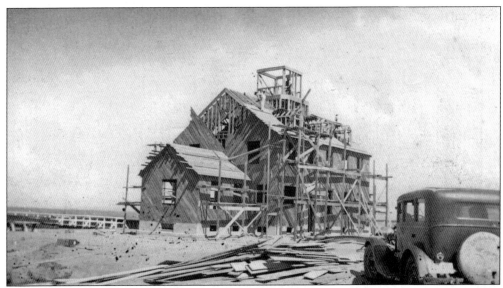

When Hilman Persson left Grays Harbor Life Boat Station in 1939, a new station was being constructed about two miles northeast of the 1897 station on the harbor side of Chehalis Point. The new building was one of several "Roosevelt-type" stations built on the West Coast in the late 1930s and 1940s. (Courtesy of Westport Maritime Museum.)

The 1939–1940 lifeboat station at Grays Harbor was Colonial Revival in style, with a straight roofline, windowed dormers on the third floor, and aligned windows on the first and second floors. A central porch faced east. (Courtesy of Westport Maritime Museum.)

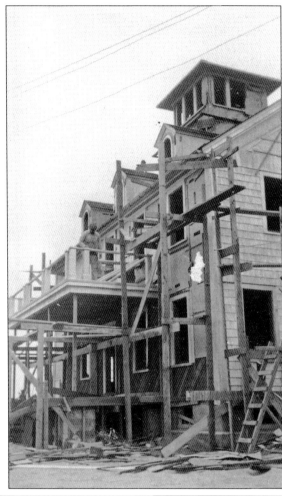

The new station at Grays Harbor fronted on the harbor, a long walkway running from the front of the building connecting it with a boathouse at its end. When an alarm bell in the station rang, a boat crew could be under way within minutes. The station building had offices, kitchen, dining area, and sitting room on the first floor and crew quarters on the second and third floors. (Courtesy of Pacific Alaska Region, National Archives and Records Administration.)

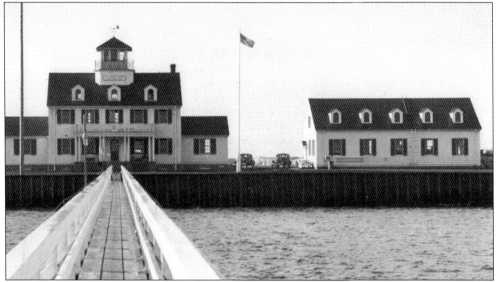

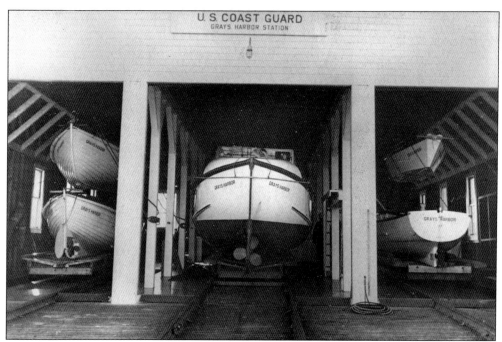

Grays Harbor Station's boats were kept on the dock and could be quickly put into the water, using a derrick for smaller craft and a ramp for the 36-foot motor lifeboat. The station's 36-foot motor lifeboat is in the center stall, with small craft to either side in other stalls. (Courtesy of Westport Maritime Museum.)

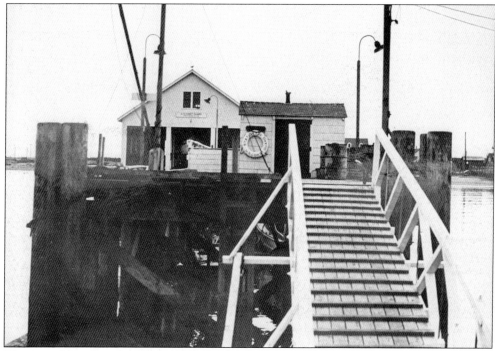

This view of the other side of the Grays Harbor boathouse shows the station's derrick and a ramp leading to a floating dock at the end of the long walkway. (Courtesy of Westport Maritime Museum.)

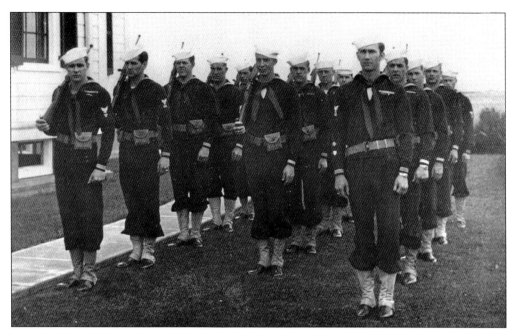

The new Grays Harbor Life Boat Station was completed just in time to accommodate part of the influx of Coast Guard personnel arriving on the harbor as part of a World War II buildup. A new, armed beach patrol supplanted the patrols once carried out by Life-Saving Service and Coast Guard personnel who had warned ships off hazardous waters with signal flares, reported shipwrecks, and retrieved the bodies of the drowned. The new beach patrollers watched for submarines and infiltrators, covering beaches on foot and horseback. (Courtesy of Westport Maritime Museum.)

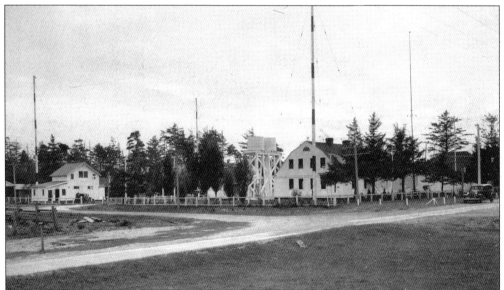

The old lifesaving station near Grays Harbor lighthouse continued in use. By the time construction began on the new building in 1939, the old facility was in use as part of Coast Guard Radio Station Grays Harbor. Radio antennae have sprouted at each corner of the station. (Courtesy of Jones Historical Photo Collection.)

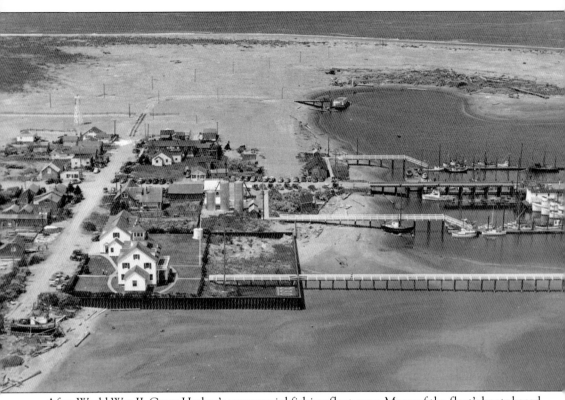

After World War II, Grays Harbor's commercial fishing fleet grew. Many of the fleet's boats based themselves in Westport, and the few score boats in this 1947 photograph multiplied into the hundreds. In the 1960s, charters fishing boats also came in the hundreds. (Courtesy of Pacific Alaska Region, National Archives and Records Administration.)

Three
DESTRUCTION ISLAND TO CAPE FLATTERY

The Strait of Juan de Fuca leads from the north Pacific Ocean's rough waters to the sheltered and resource-rich shores of Puget Sound to the south and Georgia Strait to the north. Located about 145 miles north of Cape Disappointment, the strait is about 95 miles long and 10 to 12 miles wide. Its southern shore is American territory; its northern shore is Canadian territory.

The strait received its name from a British maritime fur trader, Capt. Charles Barkley. In 1787, Barkley designated the strait in honor of Juan de Fuca, a Greek navigator who sailed with a 1592 Spanish expedition seeking a northern water route from Europe to Asia. In 1788, Royal Navy explorer Capt. James Cook named Cape Flattery on the southwest side of the strait's entrance. All this naming took place in disregard of names given by the Makah Indians, whose territory it was. However, Tatoosh Island, just off Cape Flattery, did derive its identification from a traditional Makah chieftain's name.

Fog, strong currents, and tidal changes can make the journey past Cape Flattery hazardous. Fog can totally blanket the entrance. Prevailing currents can send helpless ships drifting toward the shores of Vancouver Island on the north side of the strait. Riptides, generated by wind-driven water and ebbing waves, add to the danger.

Despite that danger, the resources of the territory along the shores of Puget Sound and the Strait of Georgia have proved irresistible. To facilitate the maritime commerce based on those resources, a network of aids to mariners was developed in the second half of the 19th century. On Washington's outer coast, the network stretches from Destruction Island to the south to Neah Bay, just inside Cape Flattery, to the north. Like the system of navigation aids at the Columbia River entrance, the network for the Strait of Juan de Fuca includes lighthouses, light ships, and lifesaving stations.

Many ships have passed through the Strait of Juan de Fuca, coming to or from ports on the shores of Puget Sound and the Strait of Georgia. The ships have carried people and cargo in both directions. The volume of this traffic increased dramatically in the late 19th century as resources such as coal and timber were exploited. In 1900, one photographer documented ships at just one Puget Sound port leaving for Hawaii, Germany, England, Japan, Chile, and Mozambique. One hundred years later, the sound's ports are even busier, as is the Strait of Juan de Fuca.

Photographic records of outer coast aids to navigation serving the entrance to the Strait of Juan de Fuca are relatively rare, however, principally because of the remoteness of those aids.

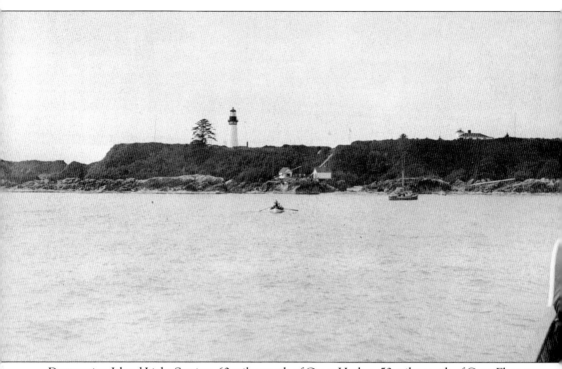

Destruction Island Light Station, 60 miles north of Grays Harbor, 50 miles south of Cape Flattery, and 3 miles off an isolated stretch of the Olympic Peninsula, may have been the most remote of Washington's outer coast beacons. Two Native American–white clashes gave the island its name. In 1775, Native Americans killed Spanish explorers when they rowed to the nearby mainland in search of water. In 1787, British sailors from the trading bark *Imperial Eagle* met the same fate as they entered a nearby river flowing into the sea. Their captain named the stream Destruction River. In 1792, Royal Navy explorer George Vancouver applied that name to the island. (Courtesy of Columbia River Maritime Museum.)

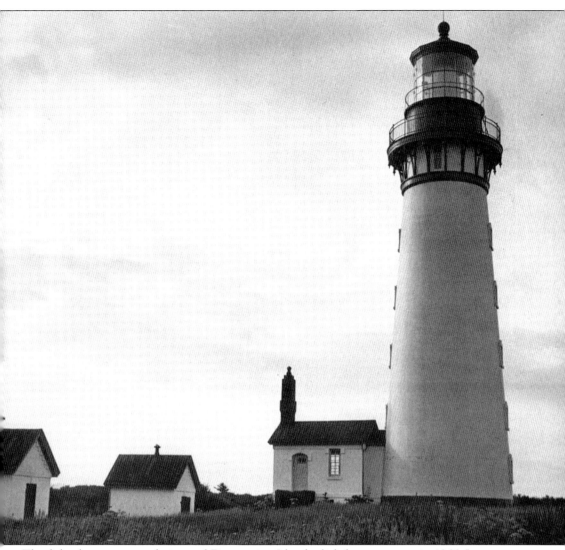

The federal government designated Destruction Island a lighthouse reserve in 1866. It was not until 1888 that light station construction began with erection of a derrick for off-loading supplies. On January 1, 1892, keeper Christian Zauner, who later transferred to Grays Harbor Light, was the first to light the oil lamp that illuminated Destruction Island's first-order Fresnel lens in the 94-foot-high tower. (Courtesy of Columbia River Maritime Museum.)

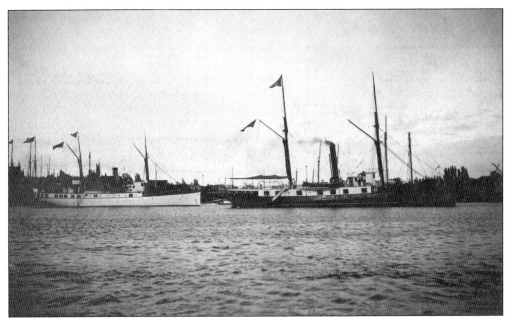

Through Destruction Island Light Station's life, tenders such as the *Columbine* (left) and *Manzanita* had to bring in all the supplies needed for light station operation. When an earlier tender, the *Shubrick*, that had serviced lighthouses in Oregon, Washington, and Alaska, was scrapped in 1885, the *Manzanita* took her place. (Courtesy of Washington State Historical Society, Tacoma.)

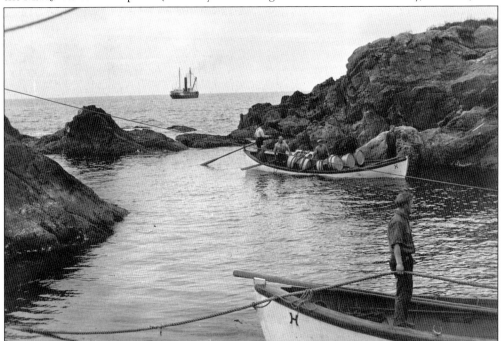

Supplies delivered by tender to Destruction Island had to be lightered ashore in small boats. The quantity of supplies required increased over the years as additional keepers arrived and a radio station and a weather station were added to the island's facilities. This photograph shows the arrival of difficult-to-handle fuel oil drums. (Courtesy of Columbia River Maritime Museum.)

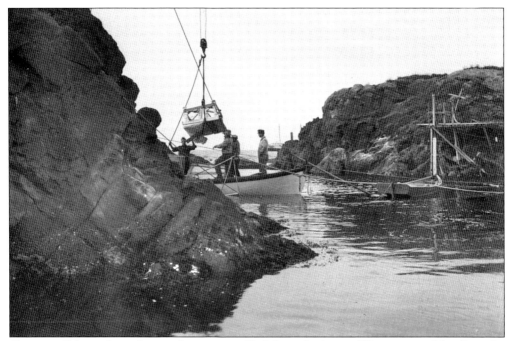

Once small boats brought supplies to a small cleft at the base of Destruction Island's rocky walls, a derrick hoisted the goods to a landing site above the water. Here Coast Guardsmen are steadying a load as the derrick is raising it. To the right is a small skiff that island residents may have used for fishing or to go ashore on the nearby mainland. (Courtesy of Columbia River Maritime Museum.)

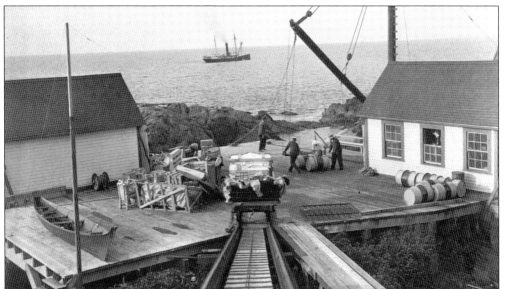

Once raised by Destruction Island's derrick, supplies still had to be lifted farther to the island's plateau-like top. A tramway provided the means to do this. In this scene, a tender is lying offshore and the derrick is in the near background at right. In the center of the picture, a load of supplies is starting up the tramway. A Native American canoe is to the left of the tramway. (Courtesy of Columbia River Maritime Museum.)

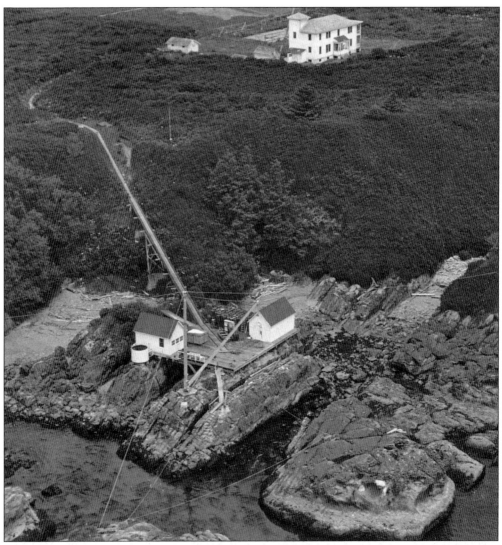

This 1947 aerial photograph shows the journey supplies had to make up Destruction Island's tramway before reaching the top of the island. The derrick and landing platform are in the foreground. The large building above the landing platform was built during World War II to house additional personnel assigned to the island. (Courtesy of Pacific Alaska Region, National Archives.)

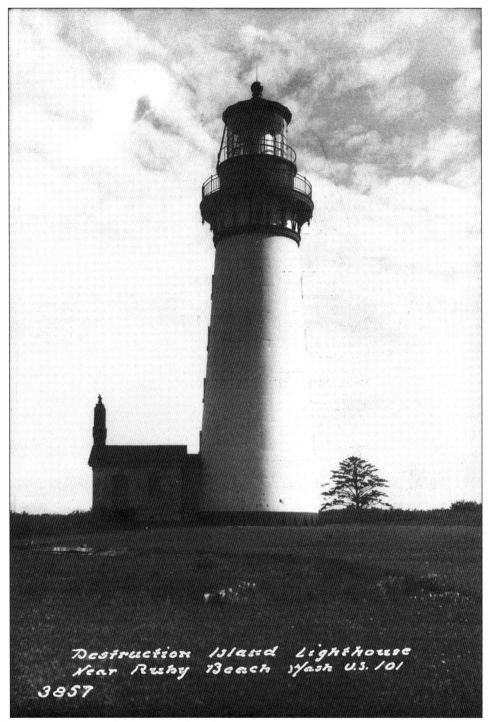

Destruction Island Light Station included a workroom attached to the tower and two oil storage houses (one on either side of the tower),. The keepers' quarters and fog signal, which were in separate buildings, are not shown in this 1940 photograph. (Courtesy of Jones Historical Photo Collection.)

These rare views showing the interior of light station's buildings are of the Destruction Island fog signal. They were taken about 1913. In the top picture, note that while water is piped into the building, it still had to be pumped by hand. In the lower picture, note the oil lamp in left corner. Lens rotation at Destruction Island was powered by a clockwork mechanism until an electric motor was installed sometime during World War II. (Courtesy of Coast Guard Museum Northwest.)

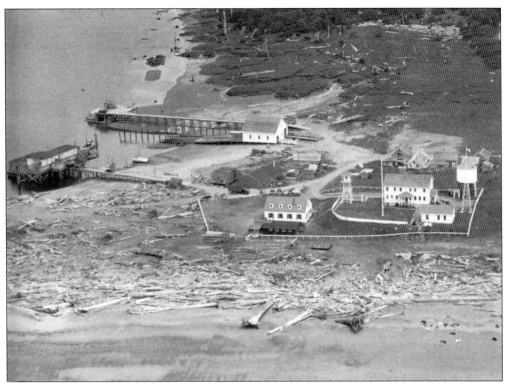

The Quillayute River Life-Saving Station was the last established on Washington's outer coast. In 1929, Congress appropriated funds for the station. In 1931, the Coast Guard awarded a construction contract. The station was a forerunner of later "Roosevelt-type" stations. The main building (center left) had the straight ridgeline found in Colonial Revival architecture but did not have the dormers and cupola characteristics of later Roosevelt-type Coast Guard structures. (Courtesy of Pacific Alaska Region, National Archives and Records Administration.)

Although not too far south of Cape Flattery, Quillayute River Life-Saving Station's most frequent function was to assist fishing vessels in distress. Hundreds of fishing boats made LaPush, at the mouth of the Quillayute River, their headquarters during fishing season. Here the station's motor lifeboat and a state fisheries vessel are bringing up a Canadian purse seiner that sank near the river's mouth. (Courtesy of Coast Guard Museum Northwest.)

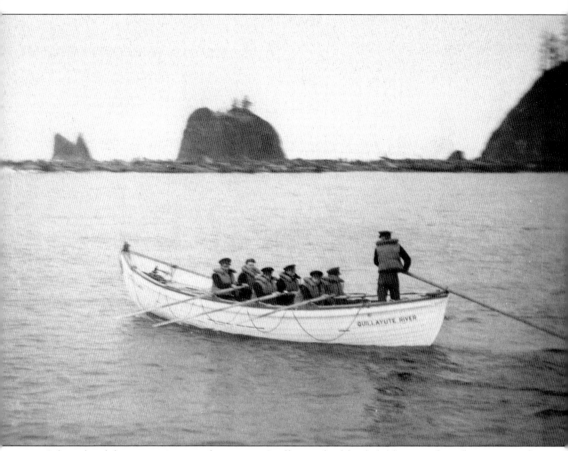
Like other lifesaving stations, the one at Quillayute had both lifeboat and surfboat. Here the crew is in the latter, heading out of the river's mouth toward the surf line. (Courtesy of Coast Guard Museum Northwest.)

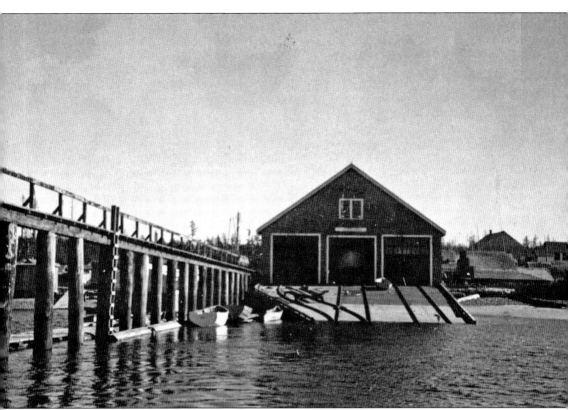

Also like other stations of the same vintage, Quillayute River had a three-bay boathouse from which its lifeboat and other craft could be ramp-launched. In this 1943 photograph, the dazzling prewar white paint of station buildings has given way to a darker color. (Courtesy of Coast Guard Museum Northwest.)

As this view of the Quillayute office/quarters building suggests, dark cedar shingles may have been what replaced or covered the white shingles seen earlier. When new Coast Guard facilities were built at Quillayute River in 1980, this building was sold and became a restaurant. (Courtesy of Coast Guard Museum Northwest.)

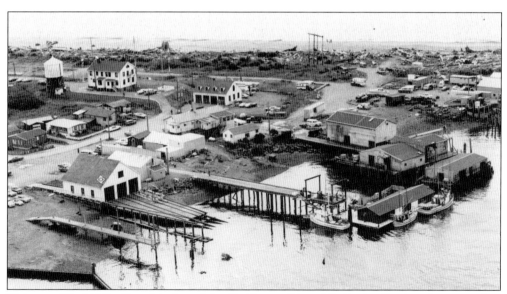

This post–World War II aerial view of the Quillayute River Life-Saving Station shows another side of the c. 1931 complex. The boathouse is at lower left, the equipment building with its four bays capped with dormers is center, and the office/quarters building is upper left. (Courtesy of Coast Guard Museum Northwest.)

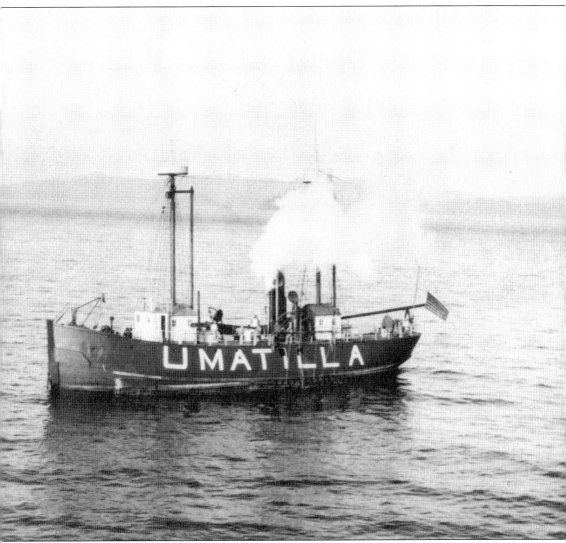

After the steamship *Umatilla* ripped her bottom out on a submerged reef about 8 miles south of Cape Flattery in February 1884, the 112-foor, 450-ton *Lightship No. 67* was transferred in 1897 from the mouth of the Columbia to a position about 2.5 miles south of the reef and 4 miles offshore. Anchored in this position, the *No. 67* was the first of a series of Umatilla Reef lightships that would mark the reef until 1971. (Courtesy of Coast Guard Museum Northwest.)

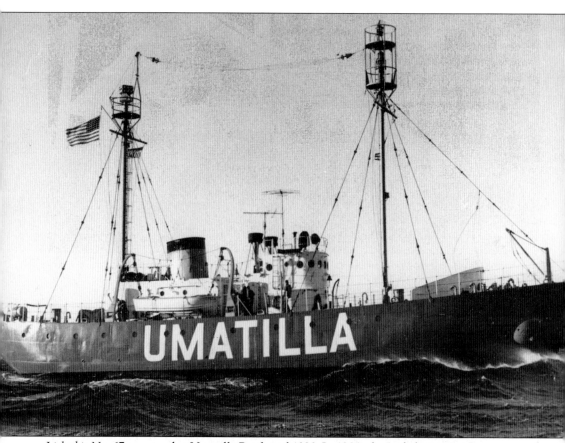

Lightship No. 67 remained at Umatilla Reef until 1930. In 1900, the Lighthouse Service converted her lights from oil lamps to electricity, in 1910 added a submarine bell to her warning devices, and in 1922 equipped her with radio. After 1930, a series of other lightships followed *No. 67* at Umatilla Reef. In 1971, the Coast Guard placed a lighted whistle buoy off Umatilla Reef. The buoy eliminated the need for a lightship and replacing the *WLV196*, shown here. (Courtesy of Columbia River Maritime Museum.)

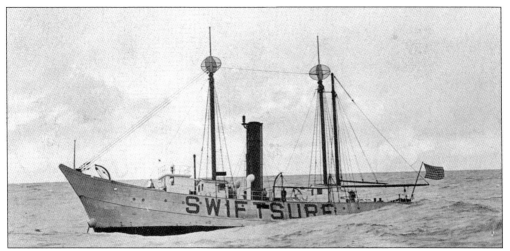

Northwest of Umatilla Reef, about 14 miles northwest of Cape Flattery, *Lightship No. 93* in 1909 took the station at Swiftsure Bank, an undersea formation rising from the continental shelf at the western end of the Strait of Juan de Fuca. *No. 93* would be followed by *No. 113*. *No. 113* sank on her way to be scrapped. (Courtesy of Pacific Alaska Region, National Archives and Records Administration.)

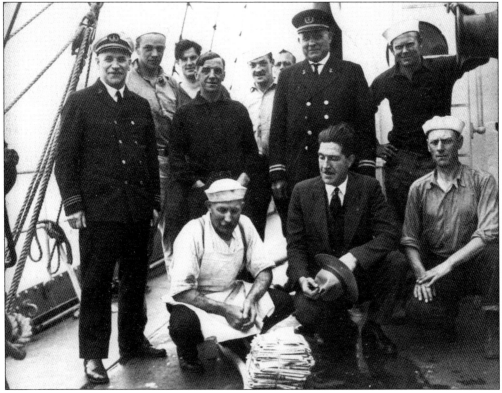

Lightship sailors had to be hardy. Their ships, anchored in turbulent waters, constantly pitched, rolled, and yawed. Lighthouse Service crews remained on board for four months at a time. After 1939, the Coast Guard changed lightship duty to 30-day stints. Here the *Swiftsure* crew poses sometime before 1939. (Courtesy of Columbia River Maritime Museum.)

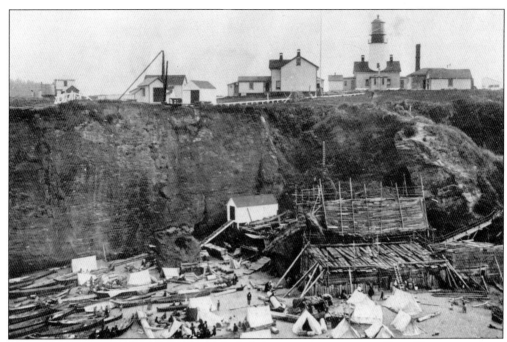

In 1850, Congress appropriated $53,140 for lighthouse construction at Cape Disappointment, Cape Flattery, and New Dungeness, Washington. George Davidson of the U.S. Coast Survey recommended the Cape Flattery Light be built at the highest point on Tatoosh Island, just offshore from the cape. As the fishing camp below the lighthouse suggests, the island was Makah Indian territory. (Courtesy of Coast Guard Museum Northwest.)

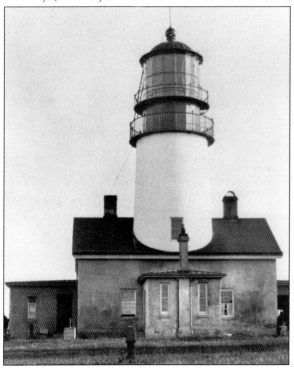

The Cape Flattery, or Tatoosh Island, Lighthouse was completed in December 1857. Its 64-foot tower rises from the center of a stone dwelling. Louis Sautter and Company assembled its first-order Fresnel lens in Paris in 1854. Lard oil was used as fuel for the Cape Flattery Light until 1866, when kerosene lamps were installed. They were replaced first by acetylene lamps and then by electric lamps. (Courtesy of Museum of History and Industry, Seattle.)

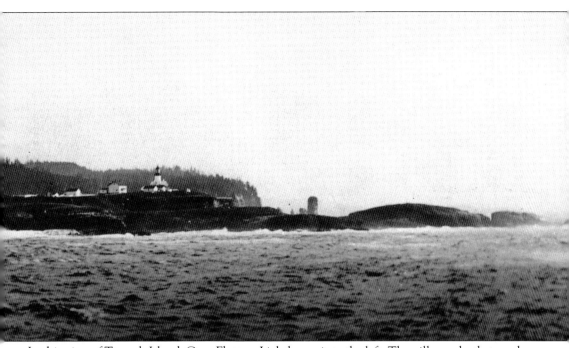

In this view of Tatoosh Island, Cape Flattery Lighthouse is to the left. The pillar rocks that mark Cape Flattery are in the background. In the latter half of the 19th century, regular communication was by Native American mail carrier canoe making the 7-mile trip from Neah Bay twice a week. In rough weather, the carrier lobbed deliveries from canoe to shore. On one trip, a dugout canoe conveyed a piano to the island. (Courtesy of Museum of History and Industry, Seattle.)

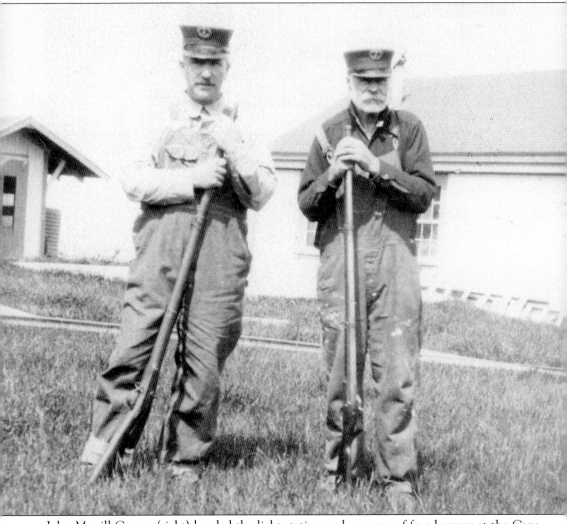

John Merrill Cowan (right) headed the light station and was one of four keepers at the Cape Flattery Light. The assistant keeper at left is unidentified. Cowan had served as assistant keeper at Coquille River Light Station in Bandon, Oregon, before transferring to Cape Flattery. In May 1911, he wrote to the Life-Saving Service crew at Neah Bay and to the crew of the Revenue Cutter *Snohomish*, thanking them for their efforts to recover the bodies of his son and other Tatoosh Island people who drowned when their boat capsized as they returned to Tatoosh Island from a mainland excursion. (Courtesy of Columbia River Maritime Museum.)

Cowan first arrived with his family on Tatoosh Island on May 16, 1900. He remained until he retired in 1932. In February 1911, two months before his son drowned, Cowan was swept off his feet by high winds rushing across the island and carried 300 feet. The same winds also blew a bull off the island into the sea. (Courtesy of Museum of History and Industry, Seattle.)

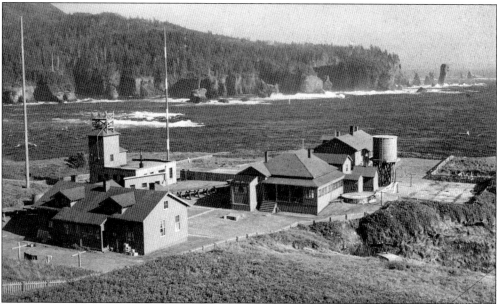

The northwesternmost point in the United States outside Alaska, Tatoosh Island in 1904 became a junction point for an undersea telegraph cable running from Alaska to Seattle. The island was also home to a weather bureau station established in 1902 and a U.S. Navy radio station established in 1908. The radio and weather buildings were at the southern end of the island. (Courtesy of Pacific Alaska Region, National Archives and Records Administration.)

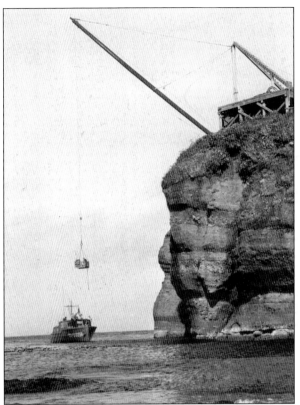

In 1778, explorer Capt. James Cook described the vicinity of Cape Flattery as "Beetling cliffs, ragged reefs, and huge masses of rock cut by the waves into fantastic shapes." Tatoosh Island's beetling cliffs required that supplies for the light station and radio station had to be hoisted onto the island by derrick. (Courtesy of Pacific Alaska Region, National Archives and Records Administration.)

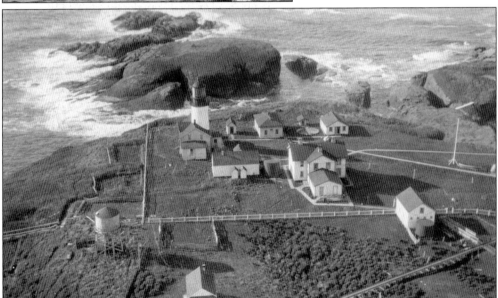

Once hoisted 100 feet to a landing site at the top of Tatoosh's cliffs, supplies moved by tramway (lower right). The 1857 lighthouse/dwelling is at left in this photograph. As built, it provided kitchen, dining room, and parlor on the ground floor and four bedrooms in the half-story above. In 1874, additional quarters were added for assistant keepers and their families. (Courtesy of Columbia River Maritime Museum.)

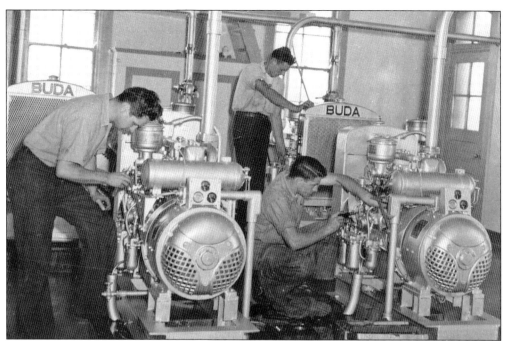

During World War II, additional Coast Guard and navy personnel moved to Tatoosh Island to service equipment that provided power to an expanded radio station. Some of them are working big Buda diesel engines. (Courtesy of Pacific Alaska Region, National Archives and Records Administration.)

The navy's radio station at Tatoosh, which closed after World War II, intercepted Japanese army and navy communications. The island's radio direction finding capability switched emphasis to track Japanese shipping. (Courtesy of Pacific Alaska Region, National Archives and Records Administration.)

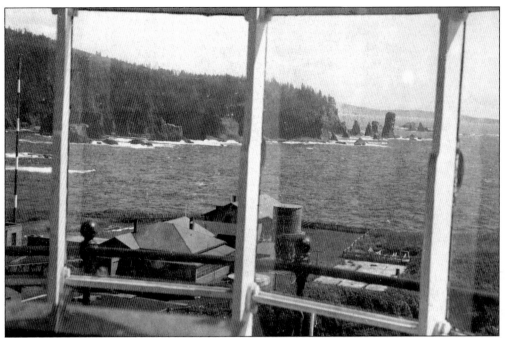

This view from the lantern of the Tatoosh Island lighthouse looks past the radio station on the island toward pillar rocks off Cape Flattery. The cape marks the southern entrance to the 12-mile-wide Strait of Juan de Fuca, which has Canada's Vancouver Island on one side and Washington's Olympic Peninsula on the other. (Courtesy of Pacific Alaska Region, National Archives and Records Administration.)

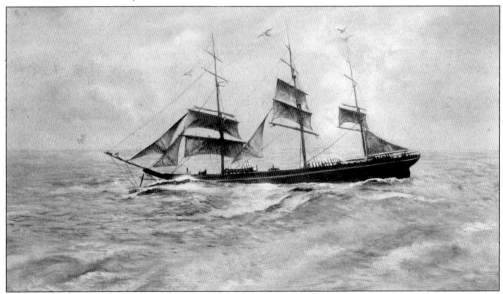

Although the Strait of Juan de Fuca is 12 miles wide, Cape Flattery Rocks and Umatilla Reef south of Tatoosh Island and Duncan Rocks north of the island threaten ships entering the strait, as do wind and current that can sweep them onto Vancouver Island's rocky shore. This 1904 view identifies the ship *Spartan* in distress off Cape Flattery. (Courtesy of Washington State Historical Society, Tacoma.)

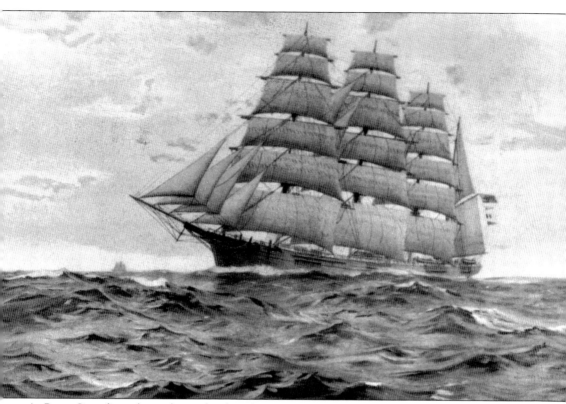

As Puget Sound's timber industry developed, enormous windjammers such as the *Great Republic*, shown here, sailed through the Strait of Juan de Fuca. They were on their way either to pick up cargoes of lumber or to carry that lumber to ports all over the world. (Courtesy of Washington State Historical Society, Tacoma.)

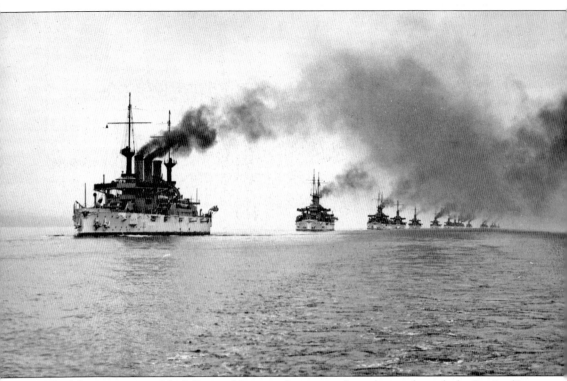

The lifesaving crews at Neah Bay could see a wide variety of vessels pass through the Strait of Juan de Fuca. Two divisions of the U.S. Navy's Great White Fleet, which traveled around the world in 1908–1909, made a round-trip from San Francisco to Seattle in May 1908. Here the ships are in the Strait of Juan de Fuca. (Courtesy of Washington State Historical Society, Tacoma.)

The 1874 Act of Congress that provided for lifesaving stations at Cape Disappointment and Cape Shoalwater also gave authority for construction on Neah Bay. Waaddah Island, at the entrance to Neah Bay, had been set aside for military use in 1868. In 1878, the Life-Saving Service built a station on the island, which is seven miles east of the Cape Flattery Light. It may be in the background of this July 27, 1914, photograph. (Courtesy of Washington States Historical Society.)

The Waaddah Island lifesaving station's location required that its boats be launched directly into the surf. A succession of keepers was appointed, but it is not clear when a full-time crew was on duty. On December 17, 1890, Waaddah Point was discontinued. In 1906, Congress authorized a new station, shown here in 1910, on Neah Bay. (Courtesy of Washington State Historical Society, Tacoma.)

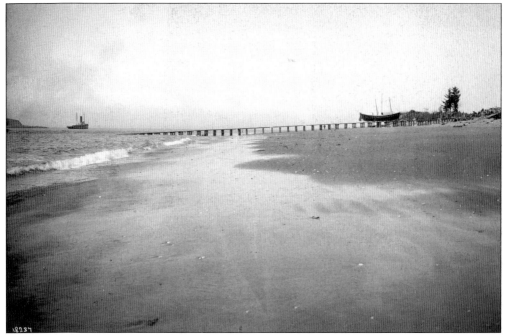

The Baaddah Point station included a long marine railway used to launch. Similar boat rails at Waaddah Island ran between two reefs. In November 1908, two of Waaddah's crew were lost while coming ashore in a dory from the power lifeboat when a squall drove it onto one of the reefs. A lifeboat (far right) is at the head of the ways in this June 1910 photograph. (Courtesy of Washington State Historical Society, Tacoma.)

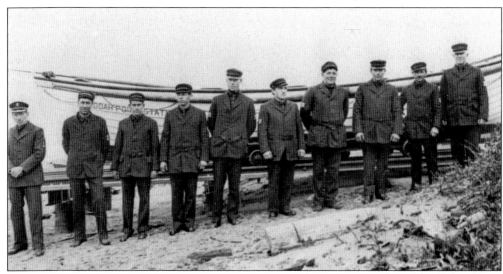

In this closer view, the Baaddah Point keeper (far left) and his crew pose in front of the station's surfboat. The wheels of the carriage that could carry the craft down the marine railway can be seen behind the crew and under the boat. (Courtesy of Coast Guard Museum Northwest.)

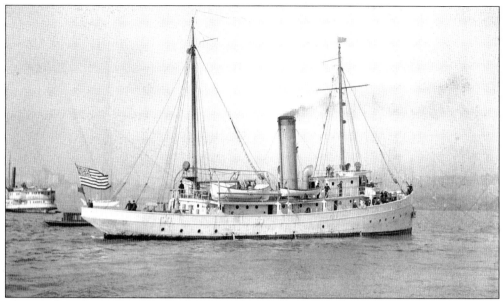

The act of April 19, 1906, that authorized construction of the Baaddah Point station also provided for construction of an oceangoing rescue tug. The January 1906 loss of the steamer *Valencia*, which sank off Vancouver Island's rocky coast while en route to Seattle, had highlighted the need for such a vessel. More than 125 of the ship's crew and passengers perished. The result was the Revenue Marine Cutter *Snohomish*, which later figured in the *Tenpaisan Maru* wreck at Grays Harbor. (Courtesy of Washington State Historical Society, Tacoma.)

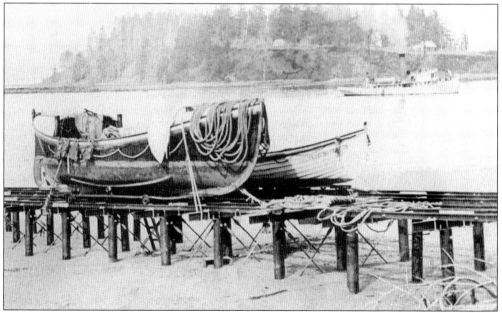

The *Snohomish* is in the background of this shot of Baaddah Point's lifeboat and surfboat on the station's marine railway. A special federal commission reviewing the *Valencia* disaster recommended that a specially equipped rescue tug be built and based at Neah Bay. The view is unusual, as many of the lifeboat crew's "tools of the trade"—cork life belts, many fathoms of line—are displayed. (Courtesy of Coast Guard Museum Northwest.)

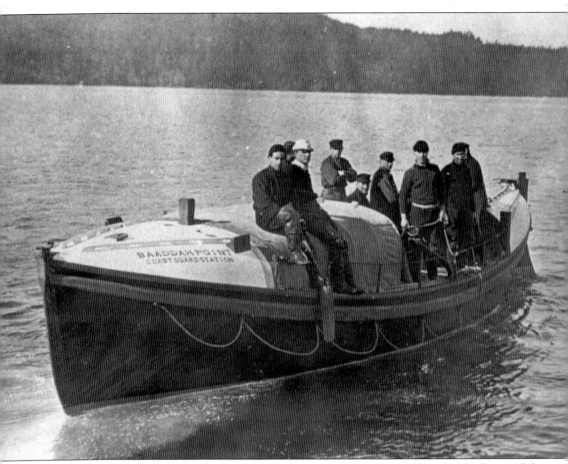

The Waaddah Island facility had reopened sometime after 1890 and by 1908 had one of the Life-Saving Service's first power lifeboats. It was transferred to the Baaddah Point facility when it opened in 1908. (Courtesy of Coast Guard Museum Northwest.)

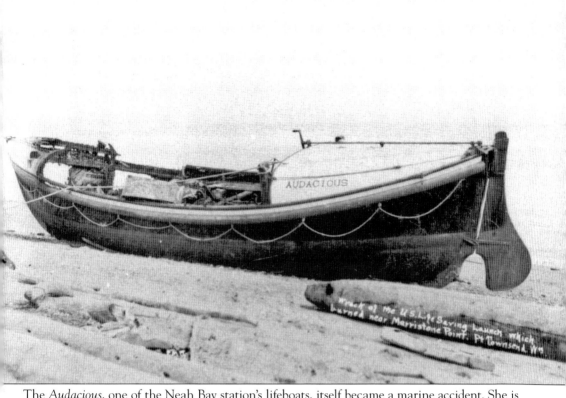

The *Audacious*, one of the Neah Bay station's lifeboats, itself became a marine accident. She is pictured here at Marrowstone Point near Port Townsend on Puget Sound. The burned bow suggests the fire may have started there. (Courtesy of Coast Guard Museum Northwest.)

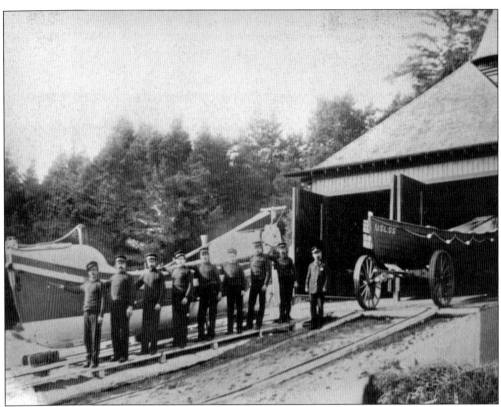

The Baaddah Point station had both powerboats and surfboats. Here the crew is parading by the lifeboat while the station's surfboat is to the right on a cart. The lifeboat was launched via the boat rails beneath it, while the surfboat could be moved to the water's edge on the cart. (Courtesy of Coast Guard Museum Northwest.)

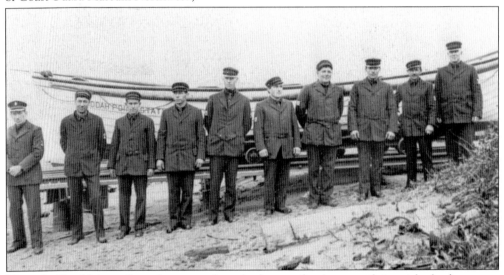

Here the Baaddah surfboat has moved to the boat rails. A crew of six with the keeper at the tiller was the usual complement for one of these 26-foot boats. (Courtesy of Coast Guard Museum Northwest.)

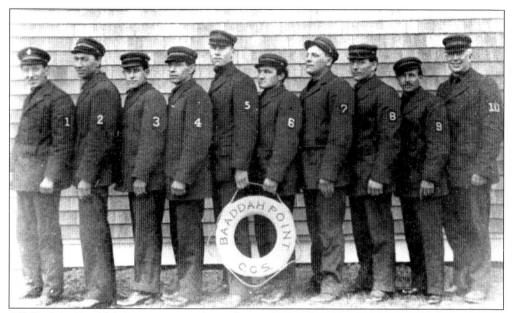

All 10 of the Baaddah Point crew are shown here. The numbers on their left sleeves identified the wearer's position in the crew so the keeper could keep track of who was doing what in particular operations. (Courtesy of Coast Guard Museum Northwest.)

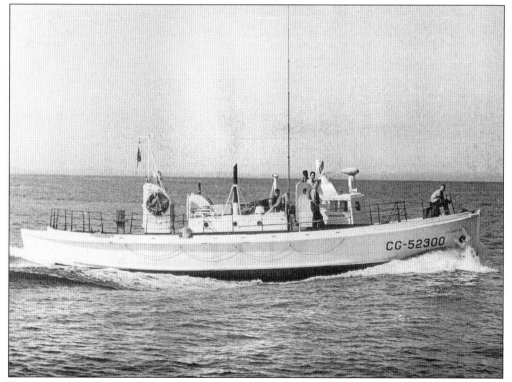

Demands of lifesaving efforts at Neah Bay required the best equipment available. After World War II, new 52-foot lifeboats such as the *Invincible*, shown here, supplanted 36- and 44-footers. (Courtesy of Coast Guard Museum Northwest.)

SELECTED BIBLIOGRAPHY

Bennett, Robert F. *Sand Pounders: an Interpretation of the History of the U.S. Life-Saving Service, based on its Annual Reports for the Years 1870 through 1914.* Washington, D.C.: U.S. Coast Guard, 1998.
DeWire, Elinor. *The Field Guide to Lighthouses of the Pacific Coast: California, Oregon, Washington, Alaska, and Hawaii.* St. Paul, MN: Voyageur Press, 2006.
Gibbs, Jim. *Pacific Graveyard.* Portland, OR: Binfords and Mort, 1993.
———. *Shipwrecks Off San Juan de Fuca.* Portland, OR: Binfords and Mort, 1968.
———. *West Coast Lighthouses: A Pictorial History of the Guiding Lights of the Sea.* Seattle: The Superior Publishing Company, 1974.
Grover, David H. *The Unforgiving Coast: Maritime Disasters of the Pacific Northwest.* Corvallis, OR: Oregon State University Press, 2002.
McCausland, Ruth. *Washington's Westport.* Virginia Beach, VA: Donning Company, 1998.
Nelson, Sharlene P., and Ted W. Nelson. *Umbrella Guide to Washington Lighthouses.* Kenmore, WA: Epicenter Press, 1998.
Newell, Gordon, ed. *The H. W. McCurdy Marine History of the Pacific Northwest.* Seattle, WA: The Superior Publishing Company, 1966.
———. *The H. W. McCurdy Marine History of the Pacific Northwest 1966 to 1976.* Seattle, WA: The Superior Publishing Company, 1977.
Noble, Dennis L. "Incident at a Life-Saving Station." *Wreck & Rescue* 1(2) (Summer 1996): 7–9.
———. *Lifeboat Sailors: The U.S. Coast Guard's Small Boat Stations.* Washington, D.C.: Brassey's, 2000.
———. *Lighthouses & Keepers.* Annapolis, MD: Naval Institute Press, 1997.
———. *That Others Might Live: The U.S. Life-Saving Service, 1878–1915.* Annapolis, MD: Naval Institute Press, 1994.
Shanks, Ralph, and Wick York. Lisa Woo Shanks, ed. *The U.S. Life-Saving Service: Heroes, Rescues and Architecture of the Early Coast Guard.* Petaluma, CA: Costaño Books, 1996.
Tacoma Public Library. "Shipping Database." www.tpl.lib.wa.us.
Weathers, Larry. "The Life Savers of Klipsan." *The Sou'wester* 34(3) (Fall 2001): 3–11.
Wells, R. E. *A Guide to Shipwreck Sites Along the Washington Coast.* Sooke, British Columbia: self-published, 1989.
Wheeler, Wayne. "The Cape Disappointment Light Station." *The Keeper's Log* (Spring 2005); www.uslhs.org.

INDEX

Alice, 43–46
Audacious, 123, 124
Baaddah Point, 119, 120
Boyd, John, 12
Brown, Capt. John, 61
C. A. Klose, 42
Cape Disappointment, 8–20, 22–26, 38, 41, 95, 110
Cape Flattery, 8, 51, 95, 107, 110–116
Chinook Indians, 9
Columbia River, 7–9, 11–21
Cowan, John Merrill, 112, 113
Destruction Island, 7, 96–102
Elinor H., 65
Grays Harbor, 7, 8, 51, 63–94
Great Republic, 117
Hammond, Frank C., 37
Imperial Eagle, 96
Invincible, 126
Jacobsen, Charles, 76, 79–81, 83
King Cyrus, 84
Klipsan Beach, 8, 40–50
Laurel, 23
Leick, Carl W., 15, 66, 67
Lightship No. 50, 28–32
Lightship No. 67, 107, 108
Lightship No. 93, 109
Lightship No. 113, 109
Lilly Grace, 7
Lizzie Marshall, 7
Makah Indians, 7, 95, 110

Manzanita, 28, 98
Monitor, 22
North Bend, 24
North Cove, 89
North Head, 7, 25–27, 33–39, 60
Peacock, 16
Persson, Hilman, 83, 85, 89, 90
Princeton, USS, 61
Quillayute River, 8, 102–107
Shoalwater Bay (Willapa Bay), 7–9, 51–59, 119
Shubrick, 98
Snohomish, 24, 112, 120
Spartan, 116
Strait of Juan de Fuca, 7, 8, 51, 95, 118
Stream, Capt. A. T., 42
Swiftsure Bank, 7, 109
Tatoosh (tug), 23
Tenpaisan Maru, 86, 87
Tokeland, 62, 63
Trinidad, 89
Umatilla, 107
Umatilla Reef, 7
Valencia, 120
Waaddah Island, 119, 120
Washington, 23
Wells, Captain, 53
Westport, 63
Wilson, Daniel, 53
Yana, C. W., 80
Zauner, Christian, 68, 97

ACROSS AMERICA, PEOPLE ARE DISCOVERING SOMETHING WONDERFUL. THEIR HERITAGE.

Arcadia Publishing is the leading local history publisher in the United States. With more than 4,000 titles in print and hundreds of new titles released every year, Arcadia has extensive specialized experience chronicling the history of communities and celebrating America's hidden stories, bringing to life the people, places, and events from the past. To discover the history of other communities across the nation, please visit:

www.arcadiapublishing.com

Customized search tools allow you to find regional history books about the town where you grew up, the cities where your friends and family live, the town where your parents met, or even that retirement spot you've been dreaming about.